IMAGES
of America

THE NEW YORK STATE CAPITOL AND THE GREAT FIRE OF 1911

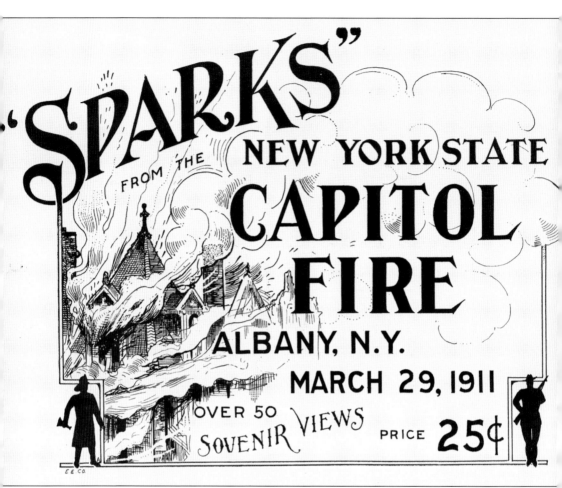

"SPARKS" FROM THE NEW YORK STATE CAPITOL FIRE ALBANY, N.Y. MARCH 29, 1911 OVER 50 SOUVENIR VIEWS PRICE 25¢

Following the 1911 fire, Albany printers Coulson and Wendt, capitalizing on the eager market for souvenirs, quickly assembled a book of photographs of the disaster. Long out of print, *Sparks* remains one of the chief sources for research on the fire. (New York State Library.)

ON THE COVER: A crowd of spectators gathers on Washington Avenue to watch as firemen train their hoses on the western approach to the New York State Capitol. In the foreground are construction sheds for the soon-to-be-completed State Education Building, which was to house the collections of the state library. (New York State Library.)

IMAGES
of America

THE NEW YORK STATE CAPITOL AND THE GREAT FIRE OF 1911

Paul Mercer and Vicki Weiss for the
Friends of the New York State Library

ARCADIA
PUBLISHING

ISBN 978-0-7385-7400-4

Published by Arcadia Publishing
Charleston, South Carolina

Printed in the United States of America

Library of Congress Control Number: 2010930340

For all general information, please contact Arcadia Publishing:
Telephone 843-853-2070
Fax 843-853-0044
E-mail sales@arcadiapublishing.com
For customer service and orders:
Toll-Free 1-888-313-2665

Visit us on the Internet at www.arcadiapublishing.com

*To the memory of Samuel J. Abbott (1833–1911), who lost his life in the
capitol fire, and to Joseph Gavit (1876–1959), a librarian who believed
in the lessons of history and who told and retold the story of the capitol
fire, hoping that "those who have lived the best years of their lives among
the loved and lost may be pleased to know that such a memorial exists of
the ruin out of whose ashes this new library has risen. While its details
may cause us regret for the things we might have done or left undone,
had we foreseen, it is the trend of history in all things that out of loss
and failure and mistakes and misfortunes, come the better conditions."*

CONTENTS

ACKNOWLEDGMENTS

"Many hands make light work." So the saying goes. The authors' work has been made immeasurably lighter by the assistance, encouragement, and support of others. In particular, we would like to thank Loretta Ebert, the director of the New York State Library, who gave this project her wholehearted support. Similarly we have been supported at every turn by Kathi Stanley, the associate librarian in Manuscripts and Special Collections who allowed us the time to develop this book. Our colleagues and friends on the Manuscripts staff helped us find materials, covered reference desk time, and cheerfully put up with the ever increasing piles of documents we amassed in our research. Senior librarian Fred Bassett in particular was more than generous in finding postcard images. A special vote of thanks goes to the documents and digitization staff, who scanned—and rescanned—all of our images. In particular, we thank John Fish, Chris Sczerba, and the amazing Helen Weltin for all of the technical skill, energy, and enthusiasm they brought to the project. Victor DesRosiers provided scans from microfilmed newspapers. Nancy Kelley of the New York State Museum's curatorial staff was an early supporter and cheerleader for this book. Geoffrey Williams, the archivist at the University at Albany, introduced us to the wonderful Ethel Everingham. Our editor, Rebekah Mower, and her colleagues at Arcadia kept us motivated and (almost) on deadline with their enthusiastic support and guidance. Finally, we would like to acknowledge the New York State Library itself, the source of this book's images. In particular, we thank the many librarians—living and long dead—who created and kept those collections and the institution that houses them.

INTRODUCTION

In the early morning hours of March 29, 1911, a fire broke out in the New York State Capitol in Albany. The local fire departments summoned every bit of equipment and every fireman that could be mustered to attack the fast-moving flames. Despite all their efforts, by the time the fire was extinguished, the entire western side of the massive stone building had sustained extensive structural damage. The southwest tower had completely collapsed. The so-called "great western staircase," a magnificent stone structure noted for its intricate decorations carved by master European craftsmen, had become a riverbed littered with broken stones and rubble. The great assembly chamber was largely saved by the total collapse of its waterlogged papier-mâché ceiling, although water lay 2–3 feet deep on the assembly floor. What was not directly burned by the fire was sodden and blackened by smoke. The state museum's priceless collection of Indian artifacts was decimated. The wreckage smoldered for days, and small stubborn fires reignited on at least two occasions. Remarkably, in all of this destruction there was only one fatality, an elderly night watchman, Samuel Abbott, whose body was not recovered until several days later.

Within a day or two of the fire, the assembly and senate were back in business in temporary quarters in the nearby city hall, which for a time was reportedly crowded with "homeless" state officials. Gradually the government offices were transferred to locations across the city, leaving the capitol—now under the protection of the National Guard—to the salvage and cleanup crews.

As if the physical damage to the building and the disruption in state government were not significant enough, contained within the damaged portion of the capitol had been the collections of the New York State Library. Nearly a century after its founding in 1818, the state library was, by 1911, one of the finest research libraries in the country, home to innumerable manuscript and printed rarities, vital documents of colonial and early state history, and unparalleled collections in law, medicine, government, and politics. Moreover it was home to one of the first schools of librarianship. Founded by the iconic Melvil Dewey, who had served as state librarian from 1888 to 1905, the school attracted students from around the world. By sunset on March 29, however, the library and virtually all it contained were reduced to ashes. Compounding the loss of the library's precious collections was the destruction of all its administrative records, catalogs, and indices, making it virtually impossible to ever accurately assess the losses. In a particularly bitter stroke of irony, the fire came as the library was months away from a projected move into new, spacious quarters under construction across the street. Now, as one librarian observed, there were "no books to go into it." Library staff and volunteers worked tirelessly to rescue any recognizable scrap of paper that could be recovered from the wreckage. The ruined books, manuscripts, and other documents that could be recovered were quickly moved to rented buildings near the capitol, where teams of workers patiently dried and, if possible, repaired them. Meanwhile, as the library prepared to move, the staff set about the business of rebuilding the collection.

The centennial of the 1911 New York State Capitol fire provides an opportunity to look back at the photographic record of the fire. Rare images and documents have been culled from the

special collections of the modern state library. Included in these images are recently discovered pictures documenting the construction of the capitol, beginning with the earliest excavations in 1867, showing the intricate processes of stonework and masonry and the European stonecutters who created it. Later views show the extensive library rooms in the old capitol in the years leading up to the fire.

The disaster of March 29 and its aftermath are fully documented in photographs, news reports, and the firsthand accounts of eyewitnesses, including remarkably dramatic memoirs of library staff who felt the loss most keenly and whose personal recollections bring the pictures to life. Many captions are drawn from the memoirs of Joseph Gavit, whose library career spanned 50 years and whose photographic memory of the intricate arrangement of the library rooms is a vital link to the past.

This is a book of many tales: the construction of the capitol and the State Education Building and the subsequent development of public space around these two buildings on the hill; the role of fires in changing the landscape of Albany; and the roles the state library and the New York State Library School played in the history of libraries in New York State and the United States, just to mention a few.

It also is about people: the men who, in 1818, believed enough in the importance of books and documents to create a state library; Hamilton Fish, the governor who feared for the safety of the books in 1849; Isaac G. Perry, the architect who lovingly designed the Great Western Staircase and the space occupied by the state library in the "new" capitol; Samuel J. Abbott, the Civil War veteran and library watchman who lost his life in the fire; the men of the Albany Fire Department and the Albany Protectives who fought hard on the morning of March 29, 1911, to save the capitol, the state library, and its important documents; A. J. F. van Laer and those who worked tirelessly for days, months, and years to rescue, stabilize, and make available the history in the one-of-a-kind documents that had been saved; Joseph Gavit and his contemporaries who lived through the fire; and the librarians in the decades since the fire who, even today, as they help researchers, must often patiently—and sadly—explain why what they need no longer exists; and last, but not least, the legislators, governors, and citizens of New York State who, through vision and the always important fiscal support, have built and helped preserve these architectural edifices and the books, maps, prints, and documents they house.

No book can tell the whole story of the public and personal life of Capitol Hill in Albany, New York. Hopefully readers of this book will find in it enough pictures and information to inspire them to pursue those portions of the story they find particularly interesting.

One

"Chateau on a Hill"
The Construction of the Capitol

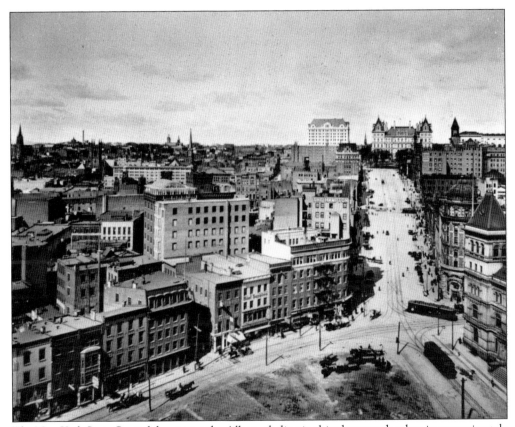

The New York State Capitol dominates the Albany skyline in this photograph taken in approximately 1915 from the Delaware and Hudson railroad company headquarters at the foot of State Street, adjacent to the Hudson riverfront. From left to right, at the top of the hill, are the New York Telephone building, the capitol, city hall, and the State Education Building.

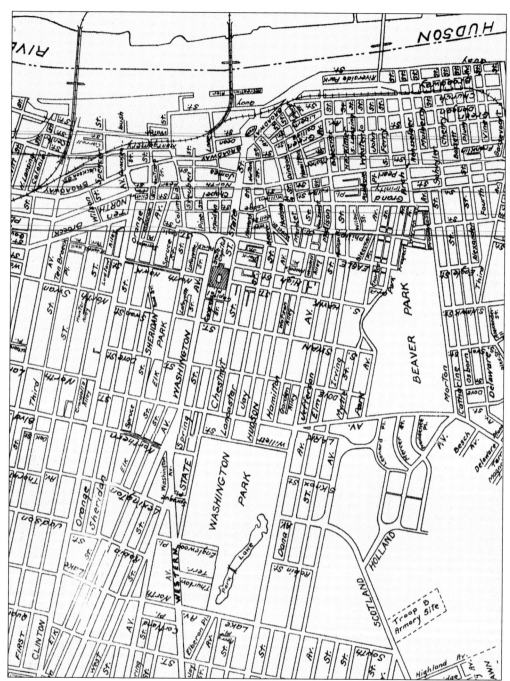

This map of downtown Albany shows the capitol bounded by Eagle, State and Swan Streets and Washington Avenue. Within walking distance are city hall, on Eagle Street between Maiden Lane (now Corning Place) and Pine Street; the State Normal School (teachers' college), on Western Avenue, bounded by North Lake and Washington Avenues and Englewood Place; and 162 State Street, the house that served for months as the administrative offices of the New York State Library.

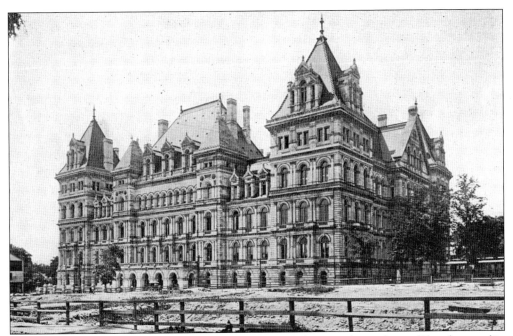

The northwestern side of the capitol (viewed here from Washington Avenue) was all but destroyed in the 1911 fire. The upper floors housed the century-old New York State Library. Across Washington Avenue was the site of the library's new home in the State Education Building, under construction at the time the fire struck.

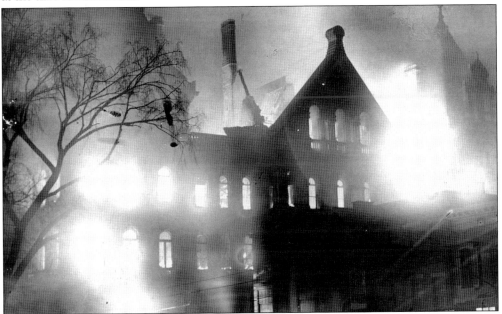

Harry Roy Sweny lived on South Swan Street, just around the corner from the capitol. A skilled amateur photographer, he was one of the first to capture the fire on film. According to the printed caption (not pictured), the *New York American* "paid $25.00 for the first print" of this dramatic photograph of the capitol engulfed in flames. Sweny shot the picture at 3:30 a.m. from the steps of the new State Education Building on Washington Avenue.

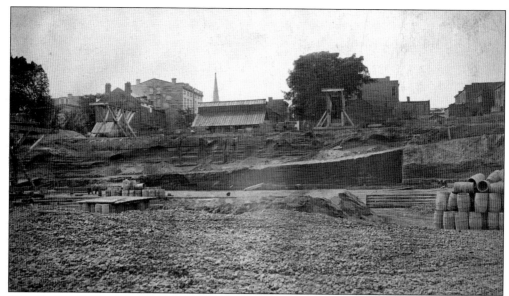

Gov. Reuben E. Fenton approved the plan for the capitol on December 7, 1867, and on Monday, December 9, according to a December 11, 1867, article in the *New York Times*, "a whole battalion of Irish laborers [was] at work with their pickaxes and shovels, excavating the frozen ground . . . with the greatest energy. This haste . . . without precedent in the latitude of Albany, would indicate that the Commissioners [were] apprehensive of some interference with their plans by the next Legislature."

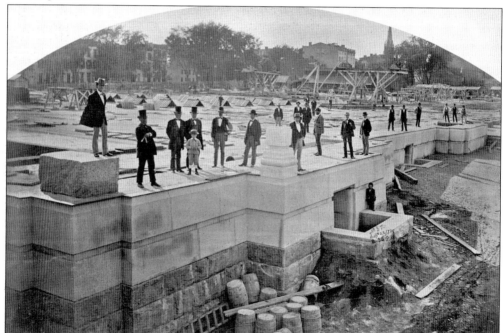

The *New York Times* reported on June 25, 1871, that on July 7, 1869, "the first stone of the foundation [for the new capitol] was laid, upon a solid bed of concrete masonry, three feet in thickness." When the cornerstone was laid, the basement story, rising 20 feet above the concrete and covering an area of three acres, was completed. This photograph was taken September 22, 1871.

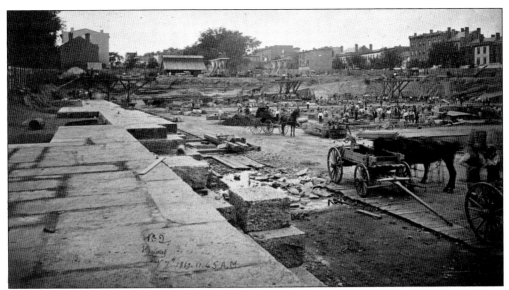

This photograph of the capitol construction site is dated Aug. 7, 1869, 11:45 a.m. The capitol was designed by Englishman Thomas Fuller, who also designed the parliament buildings in Ottawa, Canada. In 1876, Fuller was replaced by two prominent American architects, Leopold Eidlitz and Henry Hobson Richardson. With the change in architects, the exterior design became a battle of styles, in which Italian Renaissance, Romanesque, and French Renaissance were blended.

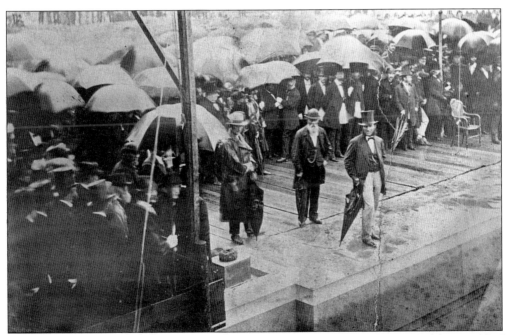

According to a June 25, 1871, article in the *New York Times*, umbrellas were used by several of the participants in the ceremonies connected with the laying of the cornerstone of the capitol on June 24, 1871, as a "cold, disagreeable rain-storm" forced several postponements to the start of the procession and program. Gov. John T. Hoffman addressed the assembly and an ode was sung by the Masons who declared the stone to have "been found square, level, and plumb."

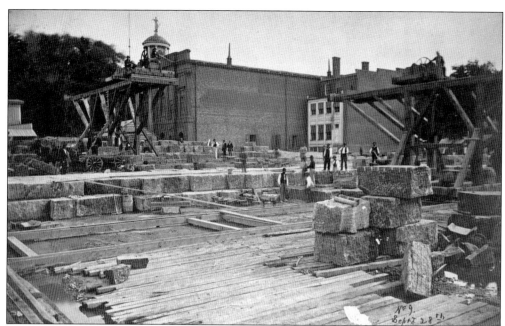

In this 1869 construction photograph, work crews, using wooden cranes and horsepower, maneuver giant granite blocks into place for the foundation of the new capitol. In the background can be seen the cupola of the old capitol. Designed by architect Philip Hooker, the old building had been in service since 1809. The statue of the goddess Themis, surmounting the cupola, was toppled by a thunderstorm shortly before the building was demolished in 1883. In the second view, taken about a year later, a work crew pauses for the camera as a granite block is swung into place with the aid of a steam-powered crane. As the buildings in the background attest, the capitol was built in the heart of a thriving downtown neighborhood.

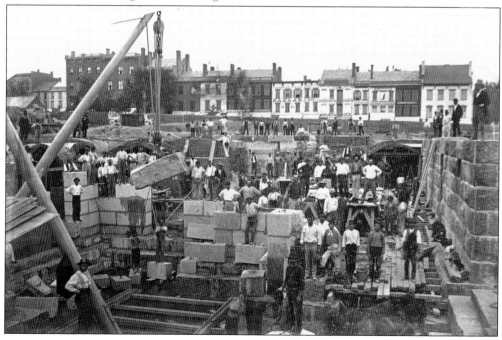

Master stone carver Louis Josiah Hinton was born in England and came to the United States to do stone work in the buildings at Cornell University. However, his most widely known work is the Great Western Staircase in the capitol. Also known as the Million Dollar Staircase, it occupies the center of the western wing of the capitol and consists of a double stairway of red Corsehill sandstone. Hinton died at age 86 in December 1931. The artistry he exercised in the capitol can also be seen elsewhere in the city of Albany. His obituary noted he was buried from the Cathedral of All Saints where he had "wrought the rough Potsdam sandstone into lace-like beauty" on the cathedral's arches.

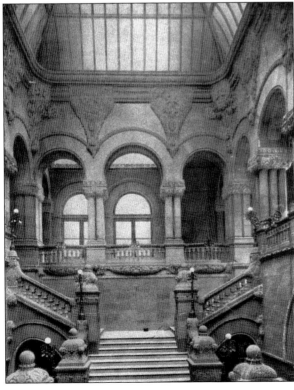

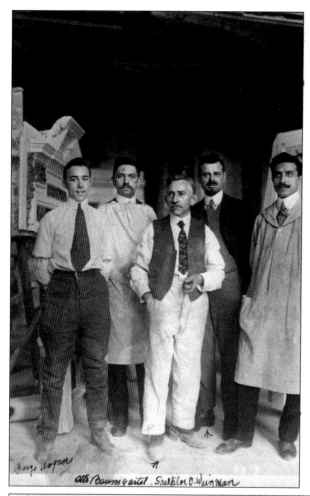

Over 500 stonecutters and carvers worked on the capitol at various times. Many had mastered their trade in their homelands of England, Scotland, and Italy. Their main task was the carving of the faces of 77 prominent people into the stone of the Great Western Staircase, as ordered by chief architect Isaac Perry. These carvings included international and national figures such as Christopher Columbus as well as New York State notables like James Fenimore Cooper. Scattered among the famous are carvings of faces of family and friends of the sculptors. Pictured at left are, from left to right, George Wagner, an unidentified stonecutter, Otto Baumgartel, sculptor O. Weinman, and another unidentified stonecutter.

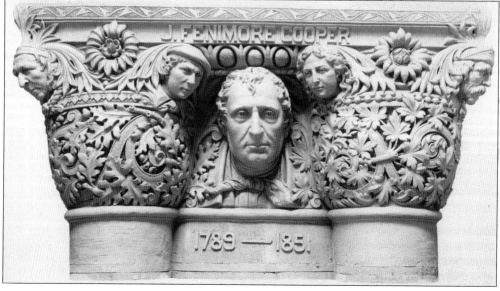

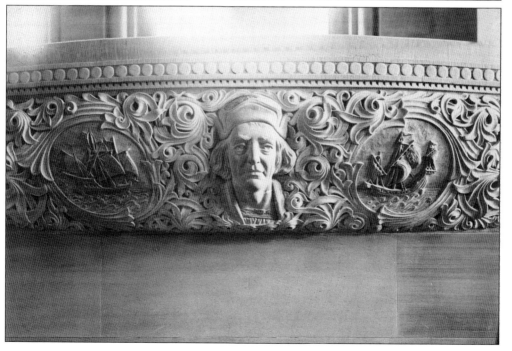

According to Edgar L. Murlin, author of *The New York Red Book*, work on the staircase began March 22, 1884, "and continued at intervals when appropriations were available . . . the actual time expended on [building it] being five and one-half years." It occupies a space 77 feet (north-south) by 70 feet (east-west); the height from the floor to the top of the dome is 119 feet. The entrance to the state library was from the western corridor on the third floor.

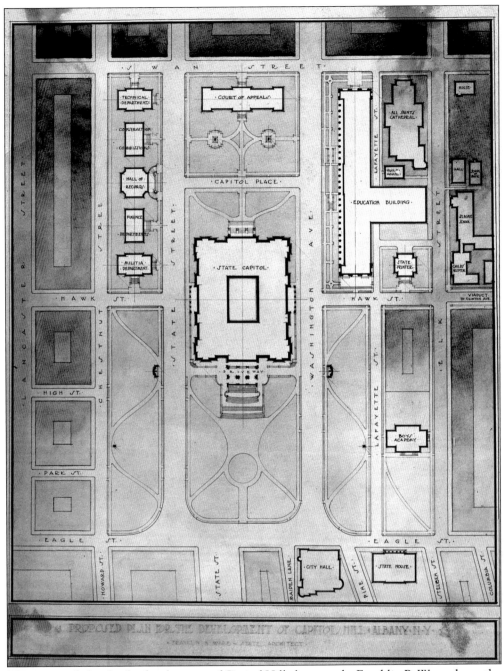

This proposed plan for the development of Capitol Hill, drawn up by Franklin B. Ware, shows the State Education Building, the capitol, city hall, and All Saints Cathedral. The Court of Appeals building was not built on the plot between Capitol Place and Swan Street, and the five smaller buildings to its left never were built. Ware was New York State architect from October 15, 1907, through May 1912.

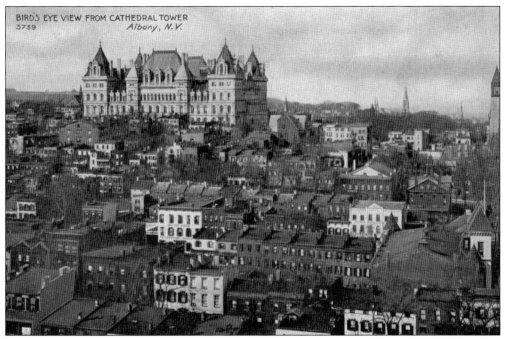

As reported in the *Knickerbocker Press*, "Perched upon the highest of the several hills upon which Albany is built, the Capitol, a gigantic structure of white granite, with red-capped towers, stands. It is 300 feet north and south, by 400 feet east and west, and covers three acres . . . Its white granite walls and red-capped towers were visible . . . from all of the railroads entering the capital." The views of the capitol on this page, taken from the tower of the Cathedral of the Immaculate Conception on Eagle Street, show it and the neighborhood before and after the erection of the State Education and the New York Telephone Company buildings and the Empire State Plaza. On the right of both images is the bell tower of Albany City Hall.

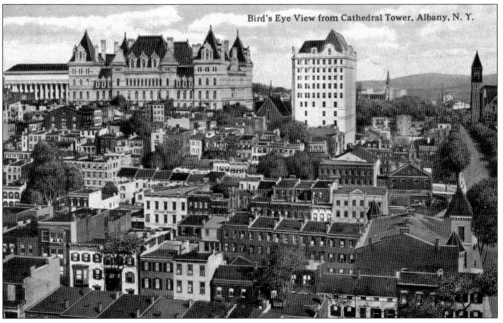

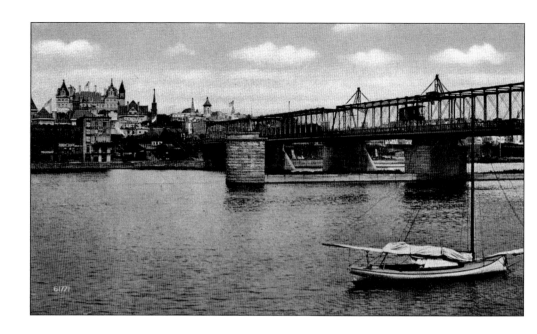

As seen in these two postcards of Albany, the capitol was easily visible from the waterfront, whether a person was traveling to the city on train or steamboat. The first train crossed the Maiden Lane Bridge on December 28, 1871, carrying travelers on the New York Central and Hudson River Railroad west across the Hudson River from Rensselaer County to Albany. Steamboats carrying passengers and freight had been plying the waters of the Hudson since August 1807, when Robert Fulton made the first roundtrip voyage between Albany and New York City. Maiden Lane ended at State Street, where visitors could decide to use either the State Street or Washington Avenue entrance to the capitol.

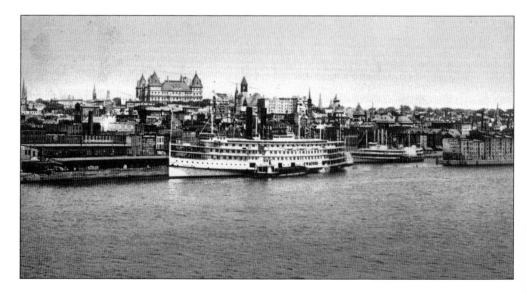

Two

"Records, Books, Papers, and Other Things"
Building a State Library

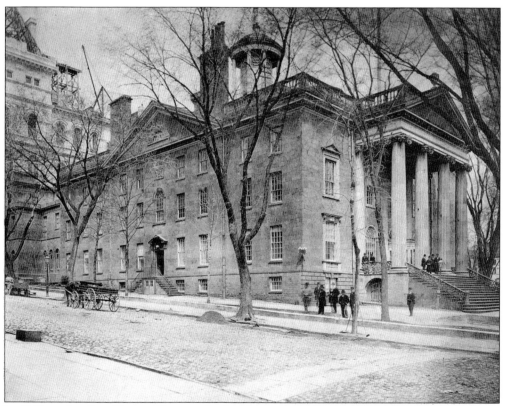

In 1818, under Gov. Dewitt Clinton, the legislature formally established the state library as a "public library for the use of the government and the people of this state." It was quartered on the second floor of the capitol. The cornerstone for the state capitol had been laid in 1806. According to the *New York Times*, the design, by architect Philip Hooker, featured "a portico of the Ionic order, tetrastyle, in tablature supporting an angular pediment in the tympanum."

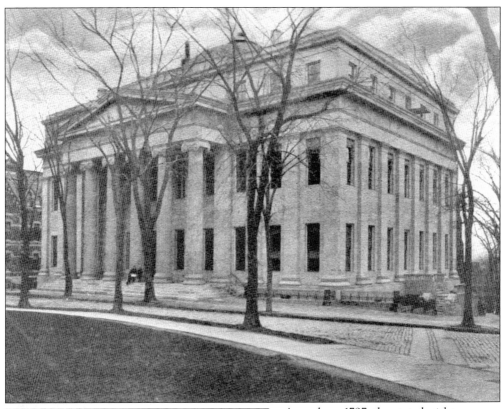

As early as 1797, the state legislature had voted to erect "a public building" at Albany to store "records, books, papers, and other things." In 1842, a new, fireproof state hall, pictured here, was opened. It continued to be a repository for government records. Today it houses the New York State Court of Appeals. Built of marble quarried at Sing Sing prison, the Greek Revival structure was designed by prominent Albany architect Henry Rector.

In a February 1849 letter to the state legislature, Gov. Hamilton Fish noted "[m]any interesting books . . . which belong to the library, are closed to the public, for want of the proper facilities for their exhibition." He also said "the Library is in constant danger from fire . . . It is stated, that the building in which the Library is placed has been three times on fire during the present season."

When the legislature failed to act, Fish, in his message of January 2, 1850, again noted the "unsafe condition of the present rooms, in reference to the danger from fire." Fish's successor, Washington Hunt (right), in his message to the legislature in January 1851, said he agreed with Fish's views "in favor of the erection of a new and convenient building for the State Library. The present accommodations are altogether inadequate."

On June 19, 1851, the legislature passed a law providing for the erection of "a suitable fire proof building without any unnecessary ornament for the state library." By late November 1854, the library had "been entirely removed to the splendid edifice." In this photograph from the early 1880s can be seen part of both the old capitol (with stone railing on roof) and the not-quite-complete new capitol (to the left).

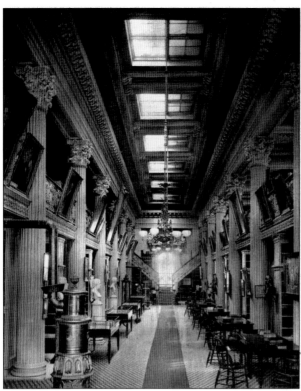

According to the 1870–1871 *Gazetteer and Business Directory, Albany and Schenectady County,* the general library, housed on the second floor, contained, in addition to "a large number of costly presents from other Governments, a valuable series of manuscripts and parchments relating to our Colonial and early State history, and an extensive collection of coins and medals, both ancient and modern" and, as recorded in an 1850 New York State Assembly document, "a very valuable and interesting collection of Maps . . . illustrative of the progress and history of our country."

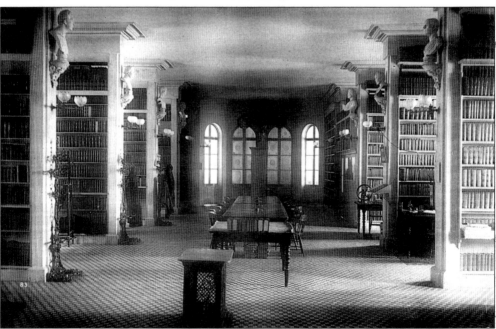

The two-story library building opened to the public January 2, 1855. It cost nearly $100,000, was faced on both sides with brownstone, fronted on State Street, and was connected to the capitol by a corridor. The first floor housed the law library. In late 1883, the building was demolished in preparation for construction of the eastern approach of the new capitol.

NEW YORK STATE CAPITOL — Third Floor.

The state library was promised new quarters encompassing the whole southern end of the new capitol. However, while construction was still underway, the judges of the Court of Appeals decided they did not like their proposed quarters on the western end of the building and, as the governor announced, "indicated a preference for a portion of the space originally intended for the State Library." As historian Cecil R. Roseberry noted, "What the Court of Appeals wanted, the Court of Appeals got. The legislature obliged, and . . . the location of the library was switched . . . to the west side of the Capitol on the third and fourth floors, plus attic space."

NEW YORK STATE CAPITOL — Fourth Floor.

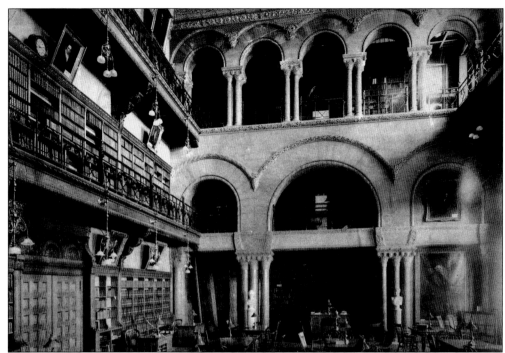

The library and regents were given the third and fourth floors and attic of the entire western section of the building. The 1888 March/April issue of *The Library Journal* reported, "The general reading room, a magnificent room 73 by 42 feet and 52 feet high, [is] carried up through the fourth story. At the two ends of this room are two tiers of galleries supported on clusters of red granite columns and freestone arches of the same color, and a gallery stretches across the east side." The room is "lighted by six windows." The attic "is 95 feet high and well lighted in its central part by a glazed roof. The north and south sections of the attic are each 53 feet square and lighted by ordinary windows, the view from which will be one of the sights of the Capitol."

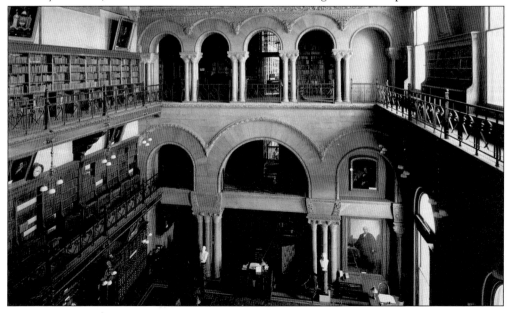

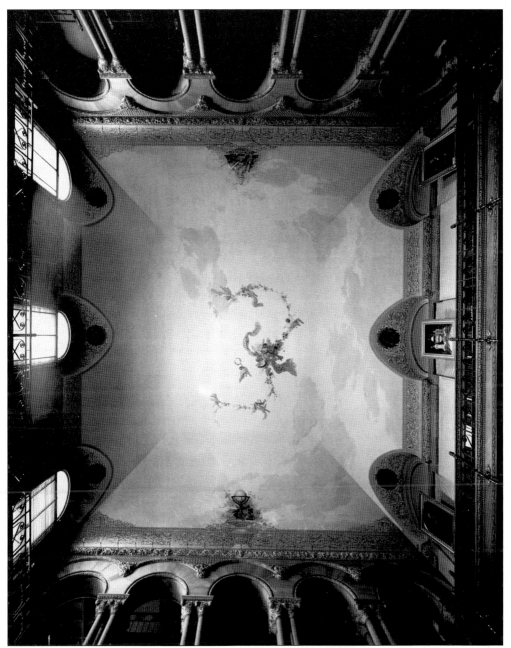

In its March 29, 1911, issue, the *Albany Evening Journal* reported that "[o]ne of the proudest moments in his life was when the late Isaac G. Perry, then Capitol commissioner, showed the completed central room of the State Library to the state officers. [The two-story room] . . . was crowned with one of the handsomest mural ceilings in the building. The treatment was flying cupids with garlands."

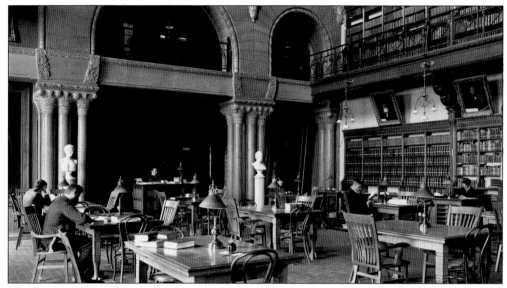

These pictures show the glorious main reading room of the library 15 years prior to the fire. As the collections multiplied, upper galleries and mezzanines steadily became clogged with hastily built shelving. Joseph Gavit, as superintendent of the shelf section, oversaw these expansions: "[Y]ear after year, [raw] pine shelving kept on being added . . . anywhere where there was room to put a case. It stopped up corridor windows, filled gaps between doorways, was built up along the railing side of galleries . . . There had even been a special framework made so that a stairwell could be utilized by placing the cases on top of the railing . . . It was cut and planed and fitted into corners, under slanting roofs, under iron stairways." Eventually, even the reading room suffered. "Yes, we did take down some pictures and fill arches with shelves in the main reading room."

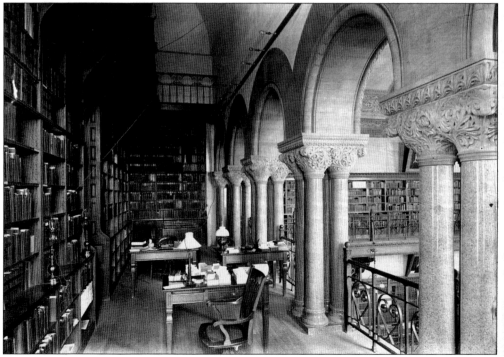

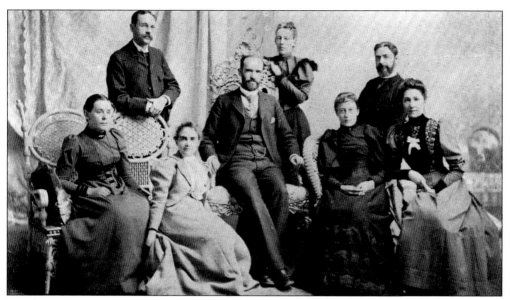

Joseph Gavit, writing in 1956, reflected on Melvil Dewey and the New York State Library School: "The students in the library school did much to carry out [Melvil Dewey's] views, many of which were "on paper" with no adequate staff to carry them out. However, . . . the sixteen years of Dr. Dewey's directorship gave the library such a living start that it has continued to prosper." Pictured here is Melvil Dewey surrounded by library school instructors in 1895. The school began life as the Columbia College School of Library Economy on January 5, 1887. The college's trustees agreed to the school as long as instruction was provided "by members of the library staff in addition to their ordinary duties." In a photograph album, a student labeled this room, in the state library in the capitol, the "old school room."

When Dewey, the library school's founder, became director of the state library in Albany, the school moved with him. It drew students from all over. The 1902 graduating class, shown below, had only one member from Albany. California, Massachusetts, Minnesota, Ohio, Canada, and Norway were all represented, and one student, Lawrence W. Katz, claimed no home, listing his residence simply as "at large." Graduates pursued careers that carried the school's formative influence worldwide. Also pictured on this page is the "president of [the] junior class, 1896-98," a photograph from a New York State Library School student's album of photographs she/he took during the time she/he was a student at the school.

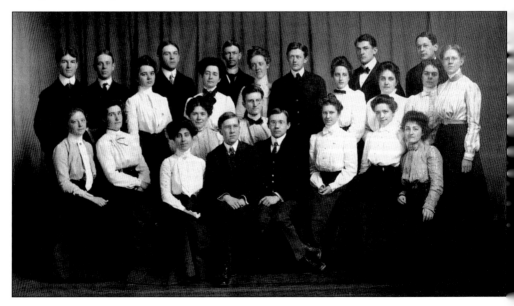

Three

"TERRIBLE TO LOOK UPON"
THE CAPITOL IN FLAMES

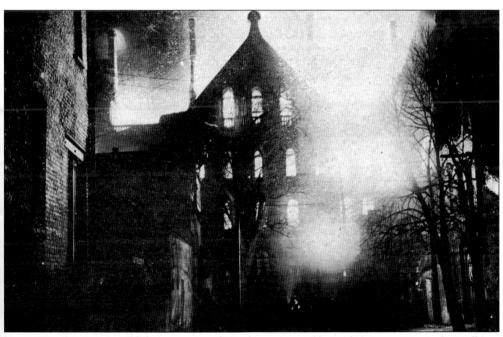

Harry Roy Sweny was well-known as a talented amateur golfer and the proprietor of an Albany sporting goods store. The first alarm was turned in at 2:42 a.m. on March 29. Sweny left his South Swan Street house, around the corner from the capitol, at about 3:30, just in time to capture on film the full fury of the flames and the doomed structure silhouetted against the night sky.

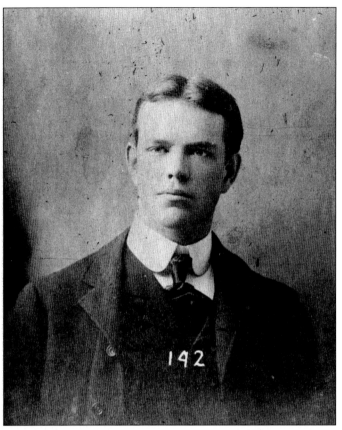

In 1896, Joseph Gavit, the 19-year-old son of an Albany engraver, joined the state library staff as a junior clerk in the shelf section. Some 50 years later, having risen to the position of associate librarian, he retired from state service. For much of his career, he was superintendent of the stacks and was reputed to know personally where every book in the library was to be found. His intricate knowledge of the collections and workings of the library were put to the test in the aftermath of the fire. As the first library employee on the scene, his eyewitness accounts, written from memory in the succeeding months and years, are invaluable in understanding the events of March 29, 1911, and afterward.

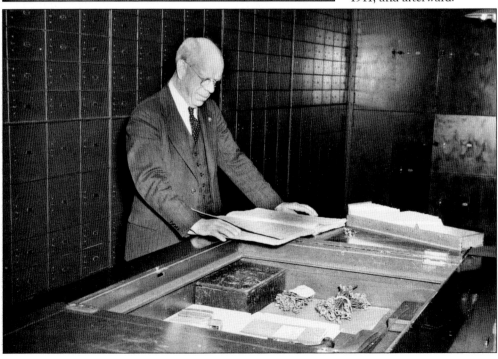

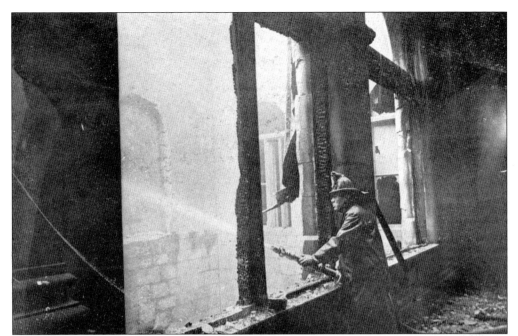

The air shafts and central courtyards of the capitol, as well as the floor-to-roof elevator shafts, stairwells, and pipe chases within the walls, provided the air supply that fanned the flames to white-hot intensity. Joseph Gavit commented, "Just around the corner—in fact just through a thickness of oak case backing, was a wooden dumbwaiter shaft running clear to the roof . . . But neither dumbwaiter, stairway, nor pine shelving was necessary to carry the flames upward, because wherever steam pipes went up through the *outside* walls, the chases were open except for an open grille work cover, probably full of dust, that doubtless did its work in every case. These alone would account for the awful speed of the flames in getting to the roof." As shown here, the air shafts and courtyards also provided access for the firemen's hoses.

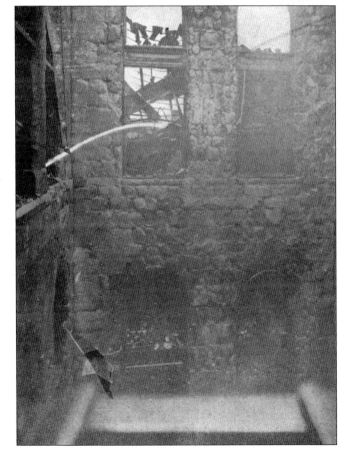

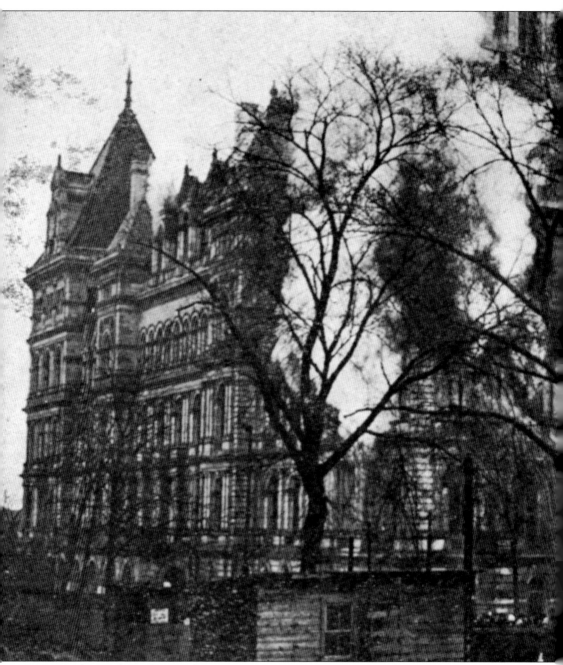

According to the 94th annual report of the New York State Library, "[t]he fire started between two and three o'clock in the morning in the Assembly library on the third floor of the northwest part of the Capitol. The State Library had no control over nor connection with this room. Apparently the flames were carried into the State Library by leaping from window to window across the corner of a court or light shaft some 20 or 30 feet square, which at this point separated the Assembly from the law library rooms. Almost immediately after reaching the law library the smoke filled the entire west front of the building from the third floor to the top, and the flames gutted the three floors occupied by the Library with almost incredible swiftness and ferocity." Joseph Gavit

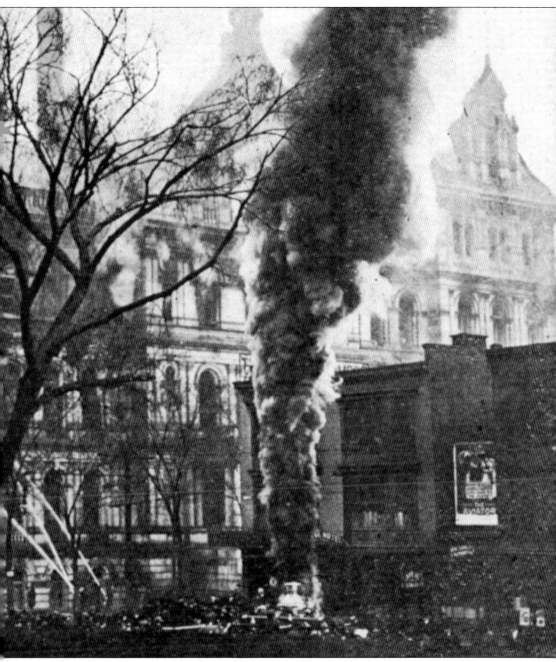

wrote, "The fire came into the library through a wood and glass partition between Room 38 and the Assembly lavatory, Room 38 was about 80 feet long, divided into two floors by a mezzanine almost the full length of the room . . . nothing could have stopped the flames, driven by a north wind, as the only access to the upper room was wooden stairways, one in the path of the fire, and the other inaccessible in the room to the north. Just around the corner . . . was a wooden dumbwaiter shaft running clear to the roof. In the rooms in which this dumbwaiter opened on the upper floors, was the only stairway at that end of the library which also ran to the roof, and surrounded at almost every landing by pine cases full of books."

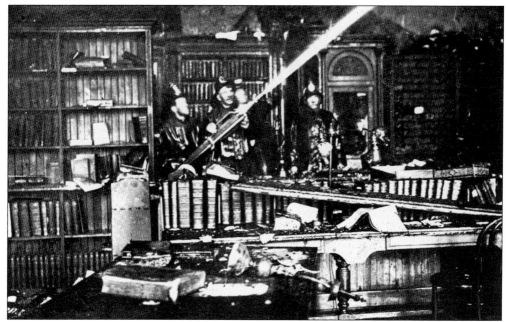

These two photographs show the north end of the library reading room. Joseph Gavit's notes indicate that the first photograph is the view towards the northwest corner: "The firemen are resting their hose against the Loan Desk and sending the water up to the fourth gallery." The second image shows the main reading room, looking toward the northeast corner. "The picture shows the effect of the fire on Scotch granite columns. Two tiers of the oak book case were burned away." Elsewhere, Gavit records his reaction on seeing what seemed to be, as in these pictures, intact books: "I had been seeking something recognizable as books, and here they seemed to be—row upon row, with the backs charred off, but which turned out to be only piles of ashes . . . the books were literally roasted to powder by the intense heat."

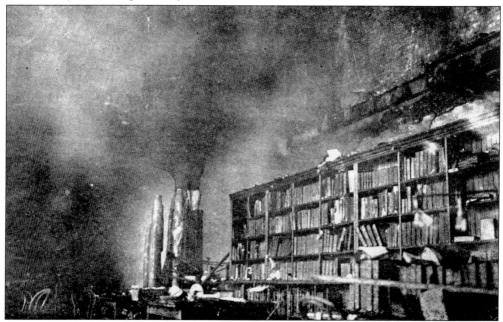

BINGHAMTON PRESS

City Edition

Vol. 50, No. 251.　　TWENTY-SIX PAGES　　MONDAY EVENING, FEBRUARY 4, 1929.　　PRICE THREE CENTS

LINDY BLAZES AIR MAIL TRAIL TO S. A.

44 Known Dead as Cold and Storm Grip Europe

Ships Are Sunk, Trains Stalled, Homes Crushed

STIMSON TO BE HEAD OF HOOVER CABINET, NEW YORK TIMES SAYS

Cruiser Fight Centers About Amendments

MARINE LIEUTENANT CAPTURES LEADER IN NICARAGUAN REVOLT

Hanneken, Noted for Taking of Charlemagne in Haiti, Gets Manuel Maria Jiron

State Regains Houdon Bust of Washington

Hoover May Appoint Lindbergh Secretary in Charge of Flying

Famed Flyer Opens New Era in Mail Service

COL. LINDBERGH

MRS. EVANGELINE LINDBERGH

Woman Popped the Question to Richest Indian

Smoot Advises Hoover to Call Congress Apr. 1

There were reports of looting following the fire. As soon as the flames were extinguished, the *Knickerbocker Press* noted, "Souvenir hunters have made their appearance at the Capitol fire. Anything will suit them in the way of a book, stone or document . . . these are in demand by the relic hunters." The library's public spaces were graced by many fine artworks, almost all destroyed in 1911. However, a bronze bust of George Washington, based on a life-cast plaster model by French sculptor Jean-Antoine Houdon (1741–1828), survived, only to disappear afterwards. In 1929, a news reporter found it, reportedly buried on a farm in Binghamton, and gave it to Gov. Franklin D. Roosevelt, who placed it in the Executive Chamber. In 1941, it was returned to the state library. It is now prominently displayed in the Manuscripts and Special Collections research room.

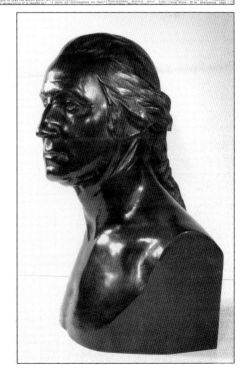

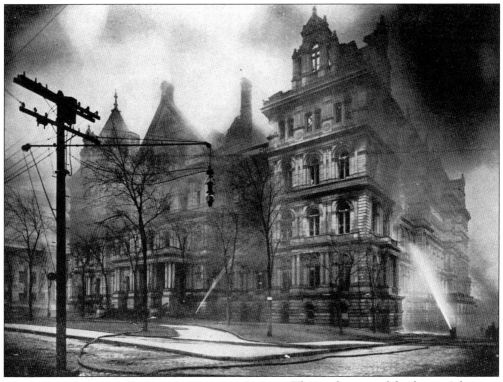

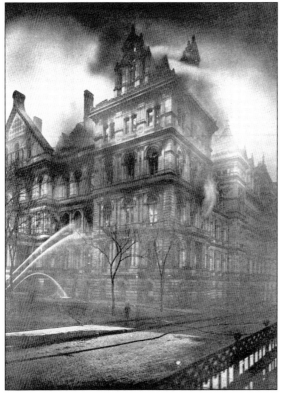

The inadequacy of the firemen's hoses against the fast-moving fire is obvious in this photograph of the western section burning. As Joseph Gavit wrote, there were virtually no fire extinguishers or hoses inside the building: "[E]fforts . . . had been made for some years to secure adequate fire protection in the library quarters; but all to no result. The Capitol burn? It was fire proof! It proved to be fire proof just like a furnace—what is in it will burn."

As the southwest tower collapses, a puff of smoke issues from the manuscripts room window. Joseph Gavit reflected on this, writing, "It seems a special dispensation of providence [that] the library staff . . . did not know of it earlier, for they would have been caught in the manuscript room, accessible only by wooden stairs . . . towards the advancing fire . . . Anywhere that they would have been seeking the invaluable, their sense of duty would have held them until escape was cut off."

Large crowds gathered on State Street, just west of the capitol, to watch the fire in the southwest tower. For days afterwards it was a popular vantage point from which to see the now collapsed tower with its skeletal dormer windows and exposed ironwork. Owing to the continuing danger posed by the possible collapse of chimneys, dormer windows, and capstones from the tower, firemen ordered Dr. G. Emory Lochner, Dr. A. B. Van Loon, jeweler Robert D. Williams, and judge Edwin Countryman to vacate their homes at 196, 198, 200, and 202 State Street, respectively. The *Albany Evening Journal* reported "[m]ost of the families were taken in by neighbors."

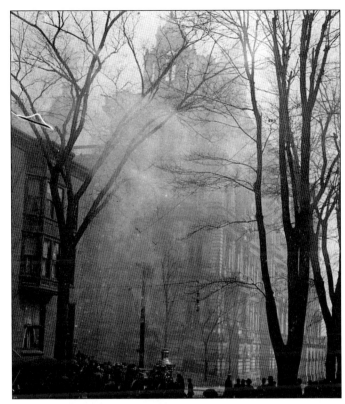

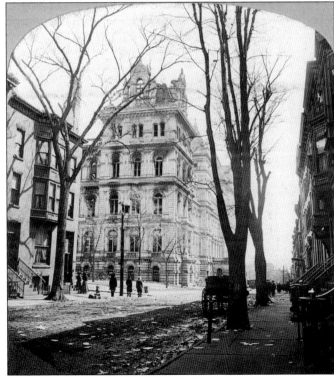

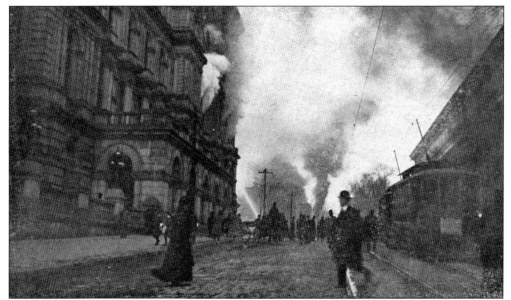

Spectators gathered along Washington Avenue on the northwest side of the capitol. The *Knickerbocker Press* reported, "On the Washington Avenue side the situation was as bad if not worse. Scaling ladders were placed against the rear . . . Every foot of hose in the Albany fire department's equipment had been pressed into service. Ten engines were pumping every pound of water they could draw."

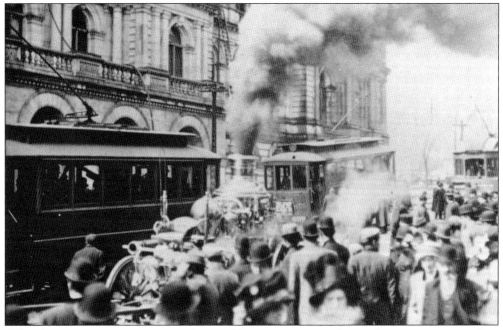

A fire department steam pumper is thronged by spectators—on foot and on streetcars traveling along Washington Avenue. In the days after the fire, according to the *Knickerbocker Press*, it was "expected that railroad trains and trolley lines [would] bring thousands of sightseers from surrounding towns to Albany. Arrangements [were] made to prevent sightseers and relic hunters from carrying away valuable articles as souvenirs."

John A. Russell of truck no. 2 said that when his equipment arrived at the scene, the third floor of the west tower on Washington Avenue was "a mass of flames and the glass was breaking in the windows when they were raising the ladders . . . [T]ruck 2 is near the end of the Hawk Street viaduct, and the engine had a straight run to the Capitol, getting to the scene first." The viaduct, originally called the Hawk Street Bridge, was completed in 1890 and was described at the time as "a daring experiment in bridge construction" because of its use of the cantilever arch. The bridge connected the fine residential section that had grown up around the government buildings with the working class neighborhoods of Arbor Hill.

The fire engines that responded to the capitol fire were all pulled by horses; the Albany Fire Department did not have a motorized truck until January 1913. The Albany Fire Protectives, founded in 1872, received its first "automobile truck" on May 8, 1912. The May 9, 1912, issue of the *Knickerbocker Press* reported that the Protectives announced that Lt. John J. Sheedy would "run the new machine . . . [and] for the first three weeks [would] respond to alarms with a speed not exceeding 15 miles an hour, that motormen, automobilists, and other vehicle drivers may become acquainted with the running of the new apparatus." Pictured is the "automobile truck" pulling out of the Protectives' engine house at 78 Hudson St.

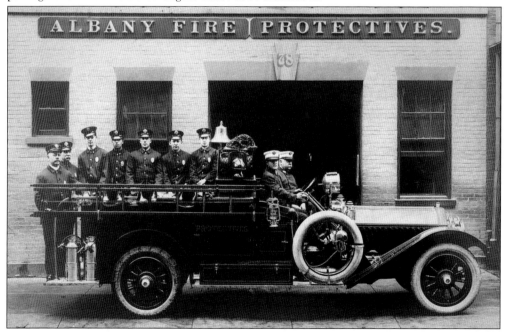

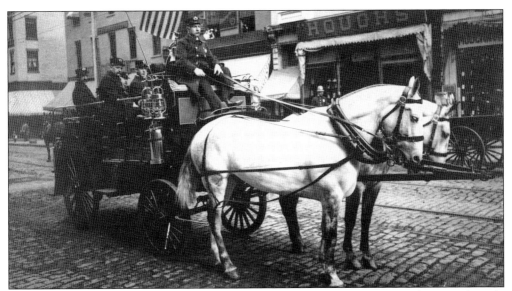

With the arrival of the "automobile apparatus," the Albany Fire Protectives retired Jerry and Frank, the two horses who had hauled the old fire wagon; Jerry stayed at the fire house, but according to the *Knickerbocker Press*, Frank, "who for more than 12 years ha[d] responded to every alarm given in the city," retired to the country, "where it [was] hoped he [would] pass the remainder of his days in leisure and comfort." The Protectives, a fire patrol in the employ of insurance companies, focused on saving property, unlike firefighters, who focused on saving lives. Their trucks carried tarpaulins to cover furniture, sawdust to soak up water, and shovels, brooms and materials to cover holes in roofs or broken windows.

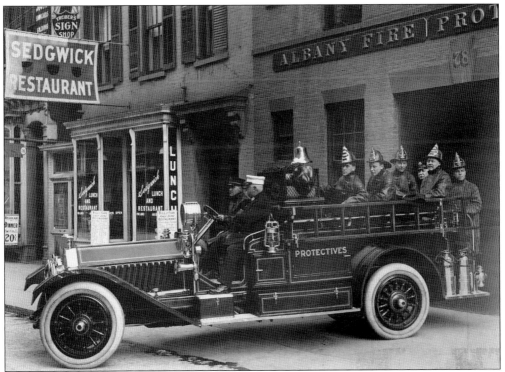

Date	Time	Station	March 1911	Covers	Exting. in bw	Sawdust	Hours Service	Time Min.
12	1:45 Pm	Verbal	60 S. Pearl St. 4 story Brick 1c Store. Electric Wire on outside of Building					.10
13	7:21 Pm	461	Head of Tivoli St. N.Y.C.R.R. Freight Car Collision.					out of District
14	7:42 Am	Tel	Lyon Block Hudson Av. Bremer St 6 sty Bk. Printing House (B.B.Lyon Co.) Rubbish in shaft	1				.25
15	10:55 Am	42	19 Daniel St. 3 story Brick 1c Dwelling. from Hot ashes. Woman Burned					.10
15	8:44 Pm	73	66 Herkimer St. 3½ story Brick Dwelling from Match. 1c	1				.25
16	11:56 Pm	427	303 Third St. 2 story frame Dwelling from Chimney					out of District
18	10:11 Am	Tel	142 S. Pearl St. 2 story Brick None Store and Dwelling. from Gasoline	4				.30
18	4:13 Pm	8.3	54 Green St. 2 story frame 1c Store and Dwelling. Unknown	7				.40
23	12:54 Am	74	50 Madison Av. 4 story Brick Iron Store and Dwelling. Unknown.	8		1	1	.10
25	5:26 Pm	423	94 Third St. 2 story frame Dwelling Unknown	1 roof	Extin same 1			out of District
26	6:7 Pm	54	102 Franklin St. 3½ story Brick Dwelling. from Grease 1c					.20
26	7:5 Pm	91	7.9 Green St. 3 story Brick Kitchen (Keeler's). from Grease.	13		1	1	.55
27	12:44 Am	62	52 S. Ferry St. 3 story Brick Dwelling. from Match 3 floor	1				.20
27	8:34 Pm	Tel 136	N. Pearl St. 1 & 2 story Brick 4th Presbyterian Church. from Lightning	3		1		.45
29	2:42 Am	324	State St. and Washington Av. 5 story Stone State Capitol. Unknown	93			10	—
31	6:39 Am	173	290 Orange St. 2 story frame Dwelling Unknown 1c	6		1		.55
31	1:36 Pm	156	940 Broadway 3 story Brick Dwelling. Unknown.	4		1		.40
Alarm Bell 20 Tel 6 Verbal 2		28	Special Call 2. General Alarm 1	167	2	10	24	.45

This page from the record of fires of the Albany Fire Protectives shows that the initial report of the fire in the Capitol—a "5 story stone" building at State Street and Washington Avenue—was placed at 2:42 a.m. on March 29 from Fire Box 324. The cause of the fire is listed as "unknown." The Protectives were on the scene for 10 hours and used 93 covers (tarpaulins), no fire extinguishers, and no sawdust.

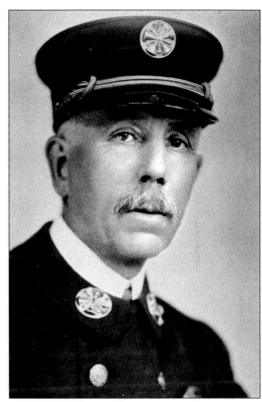

The 1924 *History of the Albany Fire Department* says Chief William W. Bridgeford, shown at right in dress uniform and below on March 29, 1911, "was everywhere, lending a hand here, chopping away partitions there when some service weary firemen weakened, helping and encouraging his men and by his own example inspiring them to the wonderful work they performed. Time and again his life was endangered. Once he was working with a crew . . . at the entrance to the Assembly chamber when the ceiling crashed down on them. One by one the plaster-covered firemen shook themselves loose of the debris . . . took up their line again and continued at their post. Several times the chief and a few of the men were lost in the maze of corridors . . . Many times they crawled on their hands and knees, but by some miracle escaped."

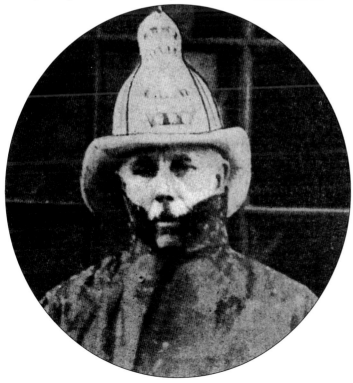

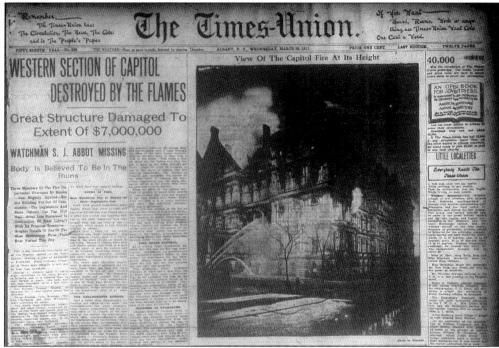

As could be expected, all four local papers covered developments in depth and out-of-town newspapers printed fire-related articles and editorials. The Albany newspapers contained many photographs and statistics and informed area residents where the various state government agencies were housed during the clean-up and restoration. They also included many human-interest stories.

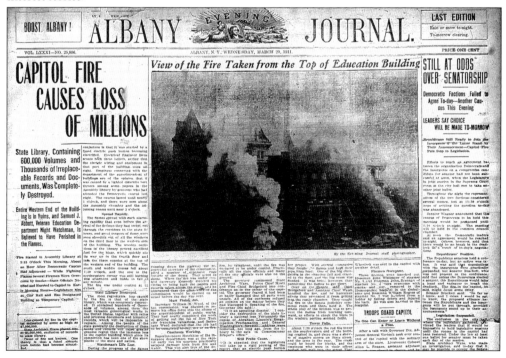

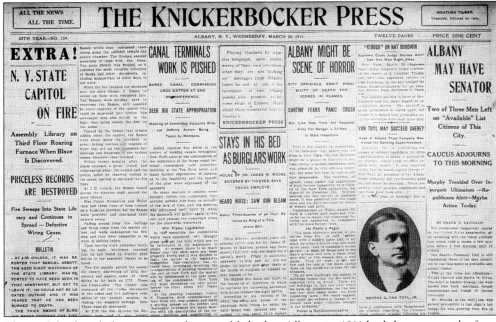

Three of the four daily newspapers being published in Albany in 1911 had the story on the front page on March 29 and two of them, the *Albany Evening Journal* and the *Times Union* included dramatic photographs of the fire. The *Knickerbocker Press* had already been "put to bed" and issued two extras to cash in on the interest in the conflagration and keep the populace informed. The newspapers also carried on their front pages the story about the meeting to select New York's U.S. senator, which had been held in the assembly chambers beginning the evening of March 28 and extending until the early hours of March 29.

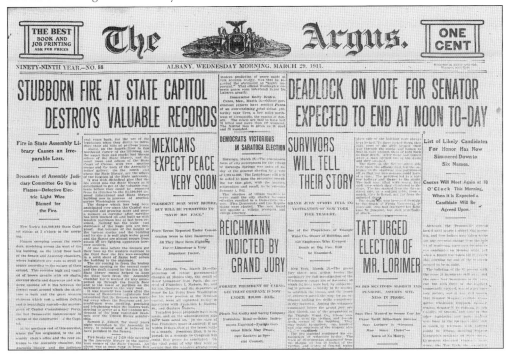

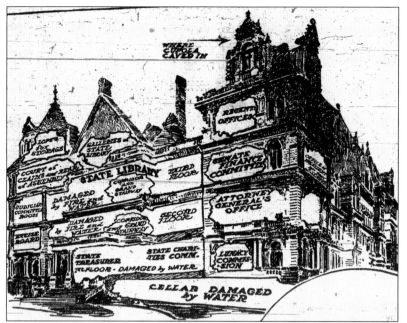

The *Times Union* published this diagram in its March 30, 1911, issue to give its readers a visual description of the damage. The diagram shows the west elevation of the building. On the left is Washington Avenue, and on the right is State Street. The fire started on the Washington Avenue side.

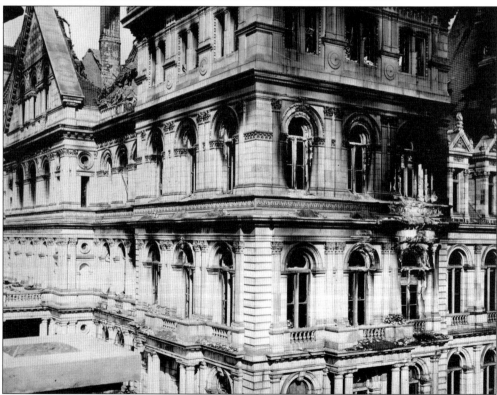

This close-up view of the exterior of the second floor shows extensive damage to the southwest corner of the capitol. In the top left can be seen the collapsed roof. Blackened and heat-damaged bricks, shattered windows, and debris-strewn ledges indicate the most heavily damaged rooms of the upper floors.

As these photographs show, the near total destruction of the capitol's southwest tower stands in sharp contrast to the damage inflicted on the northwest tower, which, although blackened and gutted, was left relatively structurally intact. As Gavit noted in his fire memoir, the latter was the last section to burn, although the fire there was "probably burning slowly all the time." The difference in the extent of damage to the two sections was due to their contents. The south tower was jammed with fuel—miles of wooden shelves of books and papers fitted into almost every available space. To relieve overcrowding in the library, raw unseasoned pine shelving was, as recorded by Gavit, placed "anywhere where there was room to put a case." The north tower, by contrast, contained little in the way of fuel, save for the desks of the library school.

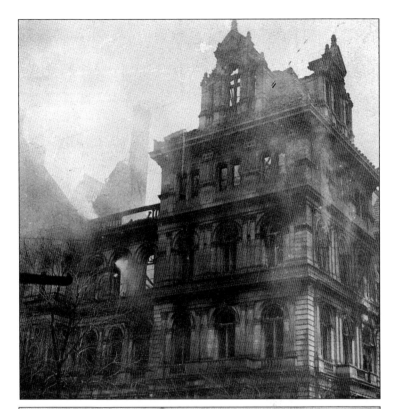

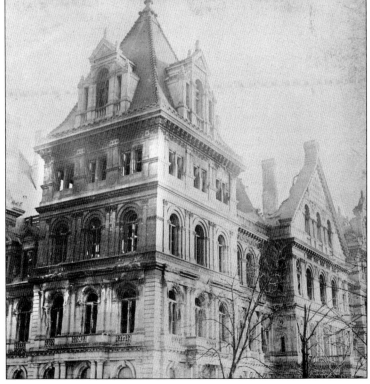

49

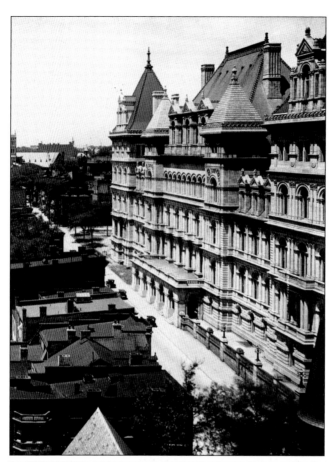

The south side of the capitol, facing State Street, is shown in a sunlit pre-1911 view. In the fire, the southwest tower—at the upper left-hand side of the picture—was all but obliterated. In the second image, firemen on State Street are directing a stream of water at the second floor of the building, just below that tower.

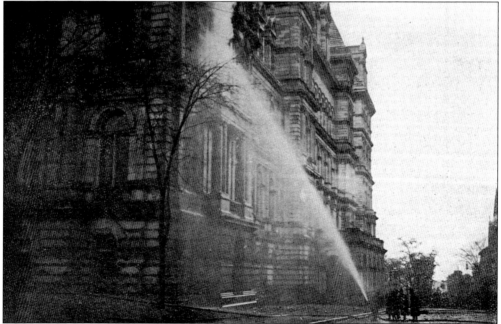

The extreme effect of the fire on exterior brickwork is dramatically demonstrated in these photographs showing the view across a courtyard of the windows and roof of the north library stack at the fourth-floor level. This was probably a secondary point of entrance for the flames, from an assembly bill storeroom on the floor below and to the right.

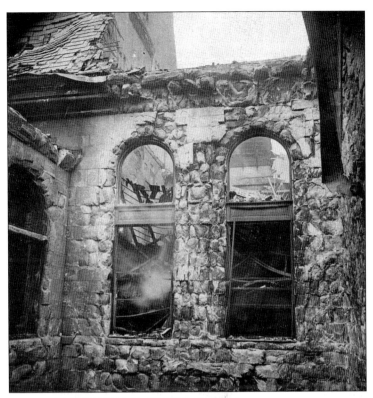

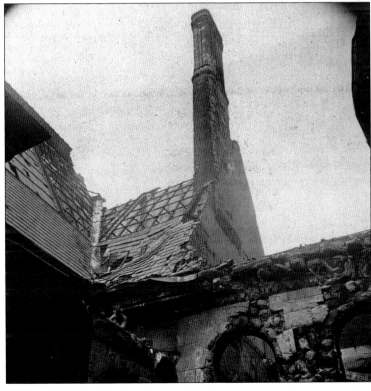

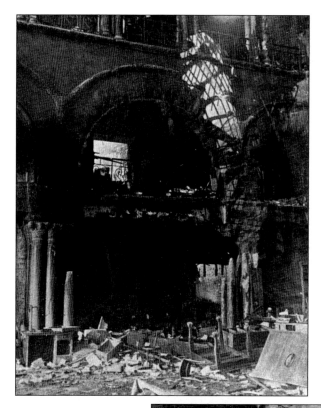

In this view of the main reading room of the state library, the circle seen in the center of the arch over the doorway is the frame of a burned-out clock. The doorway opening in the extreme right of the picture leads to the law library. The manuscript records of the War of 1812 were found intact in a closet located to the left of the clock frame.

According to Joseph Gavit, in the fire's intense heat, "Scotch granite columns [were] literally eaten away by the flames. The cast iron wheels of book trucks were melted . . . and of the 50 odd tripods of the revolving chairs in room 59, I failed to find a trace. In the lower left hand corner is the base of a bust of [pioneering educator] Emma Willard. She couldn't stand it!"

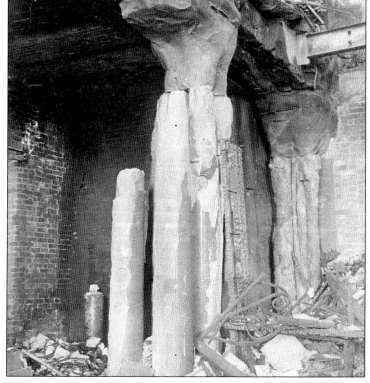

One of five photographs taken by library employee W. H. Barker shows the view from the northwest tower into the former stacks. Of this photograph, Joseph Gavit notes, "The collapsed floor was cast iron, with rose glass, and has fallen from [just] above the doorway . . . where the beam seats are seen. On this floor was the entire set of Great Britain Patent specifications . . . [and] the oversize books in Fine Arts."

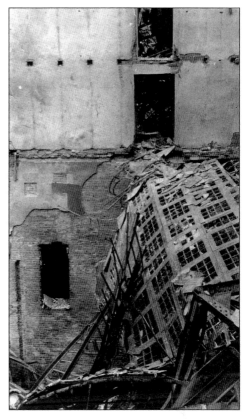

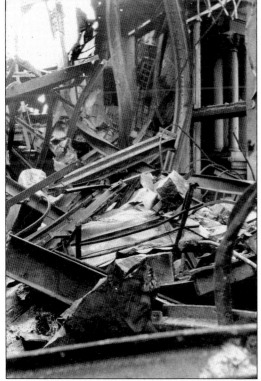

Demonstrating his ready recall, Joseph Gavit wrote of this Barker view, "Room 55, looking south from the middle of the room. Here were destroyed all of the administrative records of the library—annuals and periodical check list, gift list, order, accession, shelf list and Book Selection. Here was also the depository catalog of the Library of Congress, 300,000 printed cards; all the current files of periodicals and newspapers."

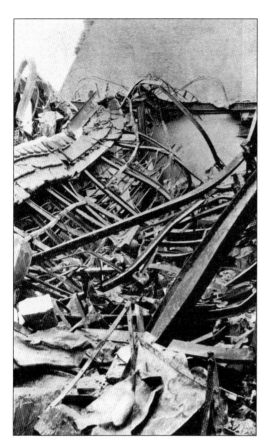

According to the 1911 report by the director, this Barker photograph shows the north end of Room 55. According to Joseph Gavit, "[the] picture was taken from about where the accession records were kept. Here vanished in smoke the priced records of every book purchase from 1856 to 1911." Gavit's own desk "was somewhere in the far end of this tangle."

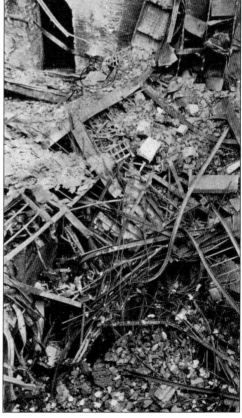

This Barker photograph was also published in the director's report for 1911. Joseph Gavit commented, "Here may be seen perhaps the worst mess of the fire. With the aid of a derrick it took two solid weeks to clean up the entire pile, which at its highest point is probably forty feet deep, resting on the third floor."

Many oddities were observed in the fire's aftermath. One is seen in this Barker photograph, showing the view from the northwest tower into the dome space over the western staircase. Joseph Gavit drew the arrow, which "points to the cheesecloth 'wall' which withstood the heat . . . The ladderlike things in the lower foreground are typical stack standards used in all stacks. Some of the galvanized iron shelves are still in place."

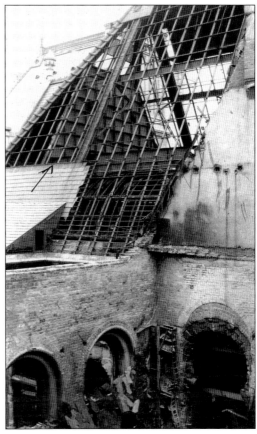

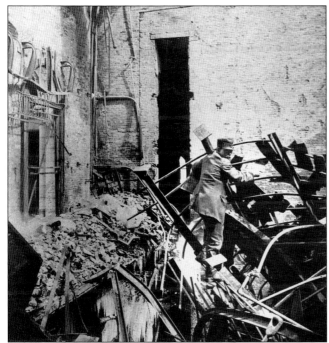

A workman is shown balancing on fallen roof trusses in the south stacks of the library. The long rectangular opening is the entrance to the three levels of the stacks. The bent I beams in the upper left side of the picture were the supports for a gallery floor.

55

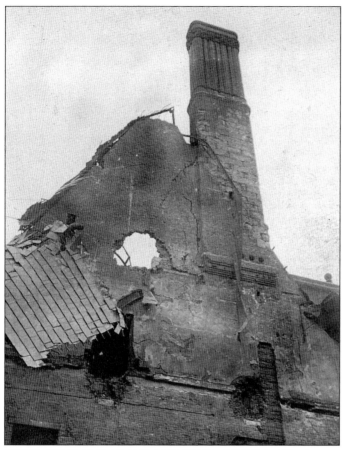

The extent of damage to the southwest tower is shown in these two views. The first shows the remains of the collapsed roof, from the outside. The interior shows the view looking down from the southwest tower into the well of the south stack. The exposed brickwork on the right side, according to Joseph Gavit's description, marks the site of "a channel for a wooden book lift running from the third floor almost to the roof. The short beams in the upper middle distance supported a large square water tank for elevators. At the right of the little doorway under these hung one of the two small fire hose reels with which the library was 'equipped' . . . The depressions in the wall, one being to the left of the lift channel, are seats of [collapsed] three-foot I-beams."

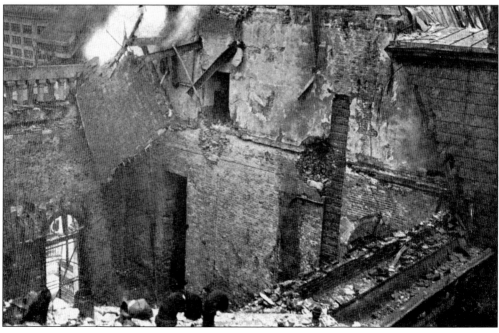

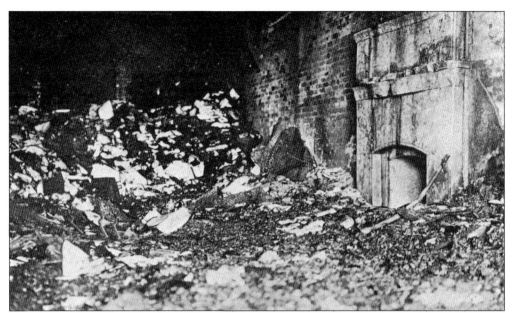

These two views show the Senate Finance Committee room. Commenting on the first image, Joseph Gavit noted, "The manuscript room was directly above this, a mezzanine of the same dimensions as this room. The heap in the background was carefully searched for coins, manuscripts, etc." Among the rarities contained in the finance committee room, according to Gavit, were "2,000 volumes of the 'Women's Library' from the Chicago Exposition and the more valuable books of the Duncan Campbell Memorial Collection. In the center of this room several gentlemen stood and did nothing while there was plenty of time . . . and 'Rome burned.'" The door at the back in the second photograph leads to a corridor behind the senate chamber. "Through the doorway may be seen the remains of the collections in Travel and Biography; also some droppings from the manuscript room."

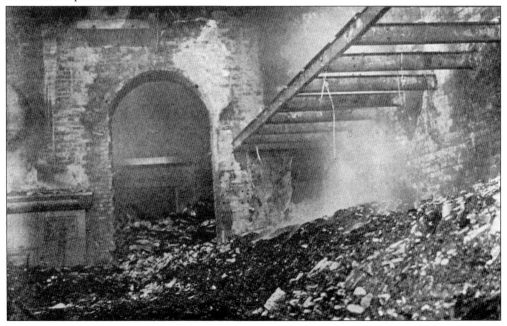

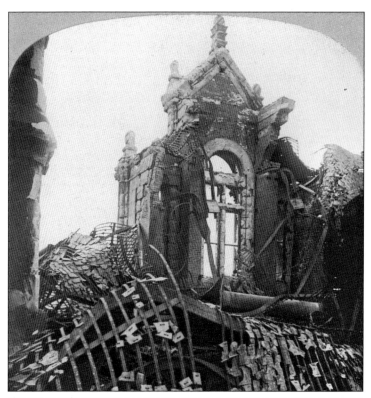

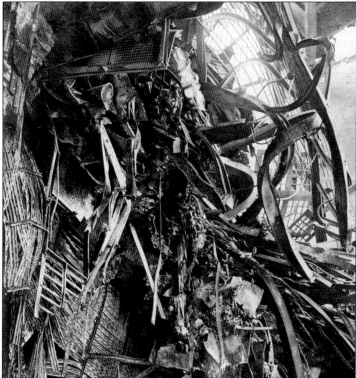

A surviving dormer window in the southwest tower shows the remains of the tower roof and floor. The solid stone, bricks, and structural ironwork dissolved in the blast-furnace heat. Joseph Gavit noted, "[T]he fire entered the south stack above the fourth floor; and . . . softened girders, melted out floor fastenings and supports. So that when the southwest tower collapsed, the chimney it knocked over fell directly over this stack, carrying roof, fifth floor, stack structure, fourth floor and all beneath it, down into a great mess of twisted girders, broken stack standards, floor plates and roof trusses which filled room 34 to a depth of forty feet." The *Albany Argus* reported, "Jumbled masses of broken stone, bricks and warped and fantastically twisted iron girders, beams and braces are everywhere in wild confusion and seemingly in an inextricable tangle."

The precarious superstructure of the southwestern tower was a source of concern following the fire. According to the *Albany Argus*, "The tall dormer windows and granite chimneys on this southwest corner must all come down. Even now the contractors in charge of cleaning up the debris and rendering the walls safe have stretched stout wire cables about the chimneys and anchored them to secure places in the lower walls of the building."

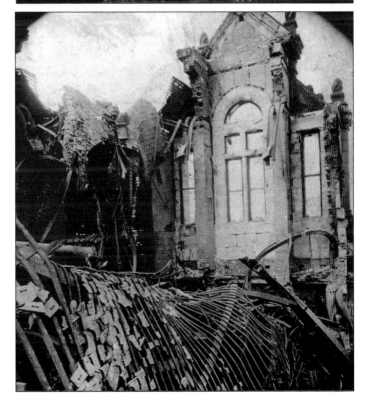

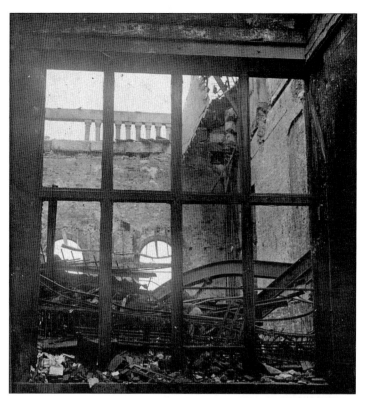

This window view into what once were the fourth floor stacks of the library gives a clear impression of the total destruction of the library's contents. An article in the *Albany Evening Journal* stated, "A survey of the ruins to-day [April 3] showed the effects of the intense heat . . . While the brick walls were but slightly cracked . . . the stone was badly chipped and crumbled. Iron girders hung from the walls resembling twisted ribbon candy."

Joseph Gavit identified this as a corridor in the Court of Claims, which occupied space in the northwest tower adjacent to the library stacks. "Oh, no! This is what the fire did to arched plaster and brick ceilings, even in open corridors ... The high window looks into the north stack at the level of 46/3." Stacks at this level contained religion and philosophy, applied sciences, engineering, and European literature.

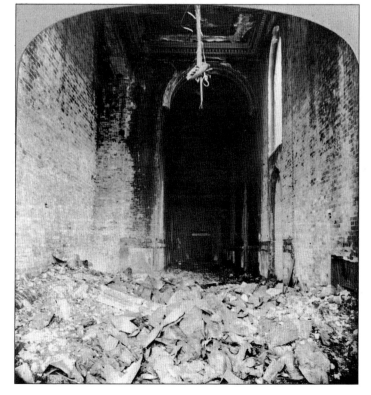

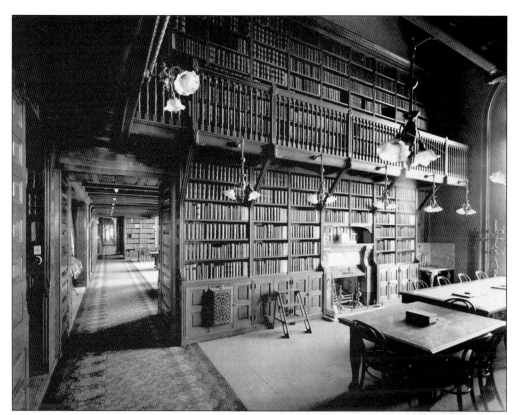

Writing in 1942, Frances Lyon, an assistant law librarian, remembered, "I was on duty that evening [March 28] and at ten o'clock, closing time, I put out all the lights and then joined Miss Elizabeth M. Smith, the reference librarian. Together, we took the elevator down and there met the night-watchman, with his old fashioned lantern, starting on his rounds. When we said 'good-night' to him, it was a last farewell." The next morning, "someone pounded on the door of my apartment . . . and announced that the State Library was burning . . . [M]y knees gave way, and I fell down on the floor almost in a faint." The first image shows a prefire view of a law library reading room. The second shows the ruined law library, down a corridor, identified by Joseph Gavit as "the path of the fire from the Assembly lavatory into the Library."

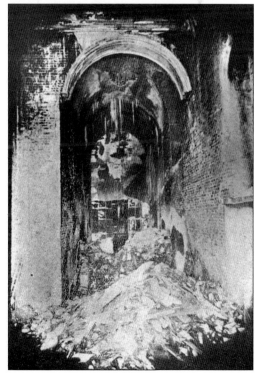

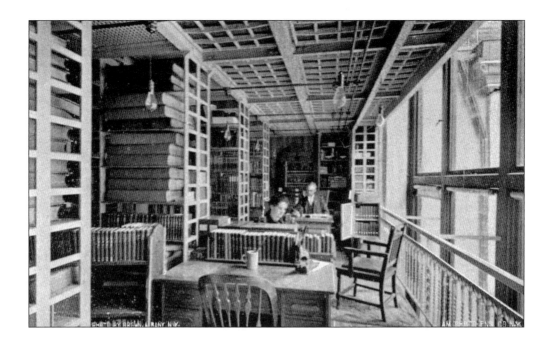

An 1895 view shows the office of the inspector of the Public Library Department, in a crowded corner of the library stacks. To the left of the desks are heavy volumes of bound newspapers. The state library was renowned for its collections of historical newspapers, all lost in the 1911 fire. The second photograph was identified by Joseph Gavit as "twisted iron in the southwest tower . . . On the upper floors of this tower were destroyed almost the entire newspaper collection and the [manuscript] volumes of the State Census, 1830–1910."

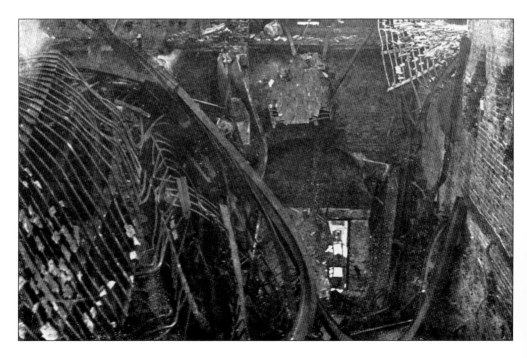

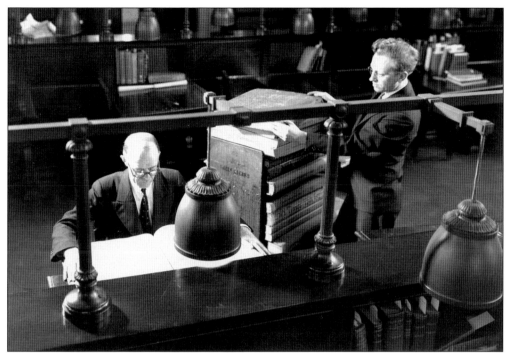

Postfire, Joseph Gavit, who was known as an authority on newspaper history and bibliography, made rebuilding the collection his personal mission. His efforts once more made the library a center for newspaper research, as seen in a 1940s photograph taken in the library reading room. In 1979, the state library inaugurated its New York State Newspaper Project to survey and microfilm all of New York's historic newspapers.

The Delaware Republican

April 10, 1869

The Trustees of [the community of Delhi] have forbidden the running of Velocipedes on the walks, under a fine of $5 for each offense.

BOLIVAR BREEZE

May 26, 1904

Large deposits of yellow and blue clay have been found on the Orrin Wetherby lots, located one-half mile west of Bolivar, on the Shawmut line ... Mr. Wetherby is making a strong effort to interest local capitalists in his project to form a company and establish a brick manufactory in this place ...

Pulaski Democrat

May 22, 1907

There has been so much interest in the automobile we have been asked for a list of the cars owned in this village which we give below. Louis J. Clark, Maxwell touring car ... E.J.Seiter, Stevens-Duryea runabout ... H.R. Franklin, a Reo runabout ... D.C. Dodge, a Rambler touring car ... these drivers of automobiles have all demonstrated their purpose to be fair with the drivers of horses and it is to be hoped there will be no friction between the two for both can use the road if a right degree of caution is exercised ...

Rochester

THE UNION AND ADVERTISER

June 1, 1915

Students at Vassar College [in Poughkeepsie] are rejoicing today because the college authorities have granted their request for the abolition of certain strict social rules ... Hereafter there will be Sunday boating on the college lake, for many years desired by the students. The girls will also be permitted to dine out with male companions without being accompanied by a faculty chaperon ...

SENECA COUNTY NEWS

August 12, 1919

Among the events of interest with which Seneca county entertained its returned soldiers and sailors last Saturday was the visit of an army aeroplane from Mineola, L.I. Lieut. Taylor ... piloted the machine ... For half an hour he thrilled the crowds by a daring series of stunts, consisting of loops, spins and barrell [sic] rolls ... Then he swooped down over the fair grounds, coming below the tree tops and within fifty feet of the ground, traveling at a speed of one hundred miles an hour ...

The Putnam County Courier

March 16, 1923

"Smarty," Mrs. Charles Wester's black cat, whose stunts of ringing the door bell and attempts to unlock and open doors has attracted such wide attention during the past two weeks, has brought Carmel before the eyes of people all over the western hemisphere ...

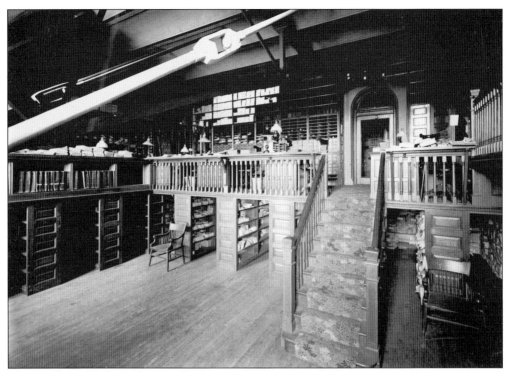

The rapidly expanding Library and Education Department administrative offices were crammed into every available corner of the capitol. The first of these photographs (above) shows a prefire view of the department's examination record room in a cramped attic space in the capitol. The second (below) shows what remained of a similar space after the fire swept through. Joseph Gavit noted, "This is one of the attic rooms, on the way from the northwest tower to the Assembly attic. Here a quantity of duplicates were destroyed. The opening is through the slanting tile roof."

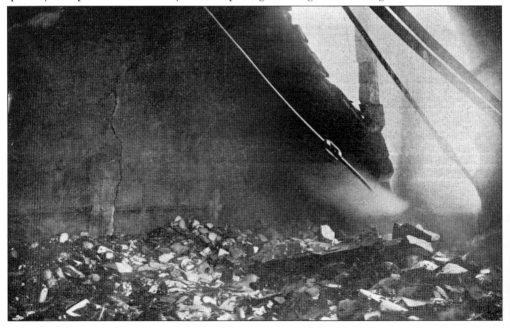

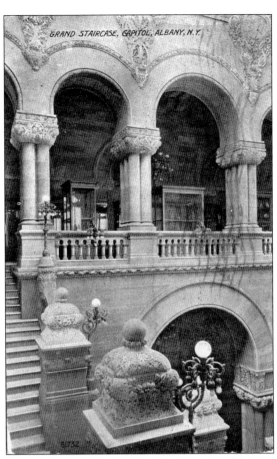

On March 29, Dr. John M. Clarke, director of the state museum, climbed to the top landing of the Great Western Staircase, where the cases of Indian relics that the state had been collecting for more than a century had been housed in glass cases. Dr. Clarke said, "They are all destroyed; those priceless, irreplaceable Indian relics. They are absolutely gone, with no way of ever replacing them." Seen here are a postcard showing the cases on the landing before the fire and a photograph taken of that corridor after the fire. The rubble is stone that fell from walls and the ceiling because of the intense heat, although the electric light bulbs in the chandeliers were not broken.

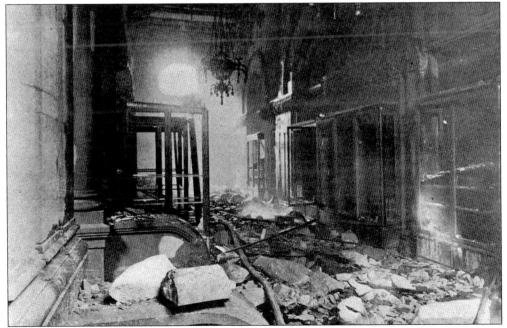

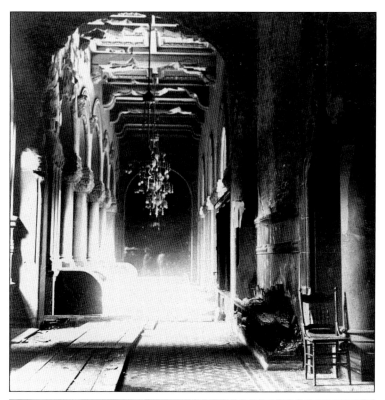

The *Albany Argus* reported the following on April 5, 1911: "One week ago to-day the western section of the Capitol was a steaming, moldering ruin, with a few venturesome archivists and librarians risking their lives delving into the heated mass . . . to rescue what the flames and water had not destroyed . . . while the firemen were pouring water against the hot walls and into the debris. To-day there was a chill about those same blackened and crumbling ruins."

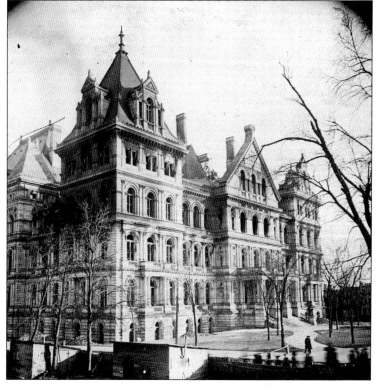

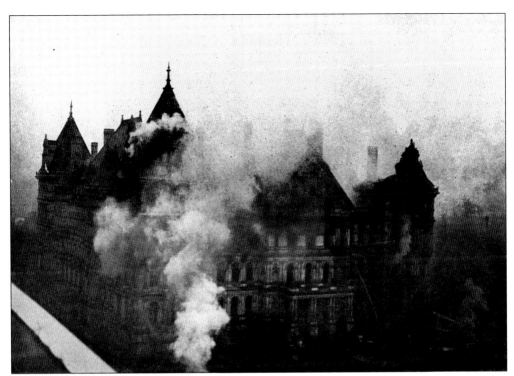

On April 6, the sentry on duty on the third floor discovered a fire, depicted in this photograph, in the northwest tower, shortly after 9:00 p.m. Steamers 1 and 6 coupled their lines together and Steamer 6 sent up a stream of water. According to the *Albany Argus*, it was believed that the "smoldering ruins were doubtless fanned into flame by the high wind which whistled about the Capitol" that evening.

Once again the Albany Protectives responded to a call—placed at 9:13 p.m. from the same box for the same building for which a call had been placed in the early morning of March 29 for a "rekindling of fire." This time the men were on duty for only 20 minutes.

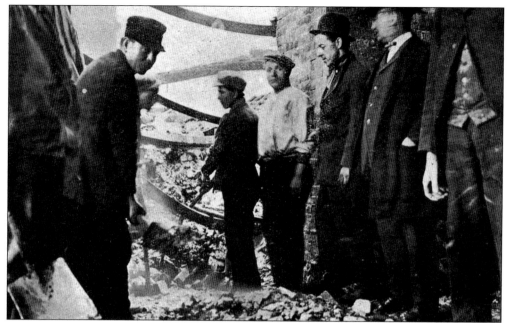

A work crew searches for the missing watchman, Samuel J. Abbott. The *Albany Argus* reported, "The suspense and anxiety . . . caused almost every conceivable rumor to go the rounds." According to Joseph Gavit, "Much has been said as to where [Abbott] was . . . during the early hours of the fire . . . [H]ad he been in the room when the fire came into the library, he would have been powerless, with only the small fire extinguishers to use where a fire engine stream would have been useless."

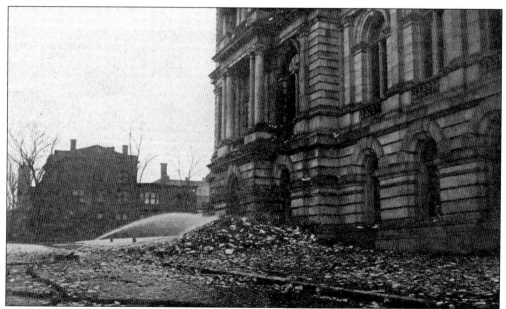

In the search for Samuel Abbott's body, this pile of papers was shoveled from the offices of the state board of regents in the southwest corner of the capitol. The fire hose is cooling the debris. As late as April 8, the *Albany Argus* reported a brief outbreak of fire "eating through the pile of half-burned rubbish underneath what was once the room where the regents held their meetings."

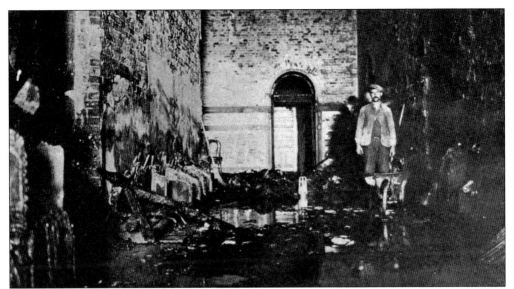

Samuel Abbott's body was found in this narrow passage on March 31. In his pocket was the key to the door at the back, near which he succumbed to the advancing flames. On April 8, the *Albany Argus* reported his "silver handled cane . . . was found under a pile of rubbish . . . a short distance from where Abbott's body was found . . . [H]e had probably had dropped it in his fight for life."

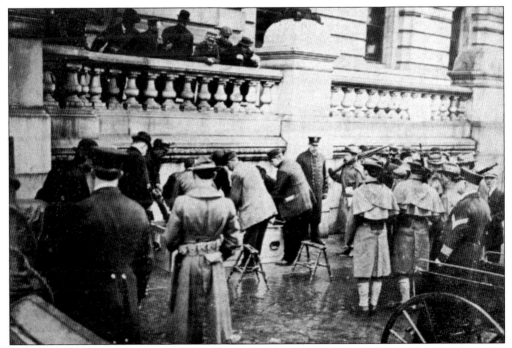

A military honor guard assists as Abbott's remains are removed. According to Joseph Gavit, "So perished our library, and with it one man, Samuel J. Abbott, the lone watchman . . . The rooms occupied by 500,000 volumes and the offices of all but two divisions of the Education Department were too much territory for one feeble old man to watch. That was one of the mistakes and he died in proof of it."

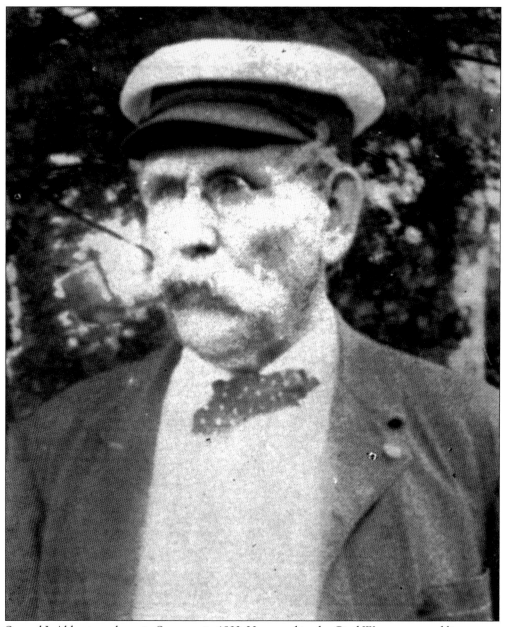

Samuel J. Abbott was born in Syracuse in 1833. He served in the Civil War as a second lieutenant in Company A, 12th New York Volunteers. Injured, he returned to his native Syracuse where he served as assistant overseer of the poor until 1894, when he moved to Albany to work in the newly completed capitol. Today it is said that his ghost still haunts the darkened corridors where, in 1911, he met his death.

Four

"SOME STAINED OR BLACKENED REMNANTS"
SALVAGE AND RESTORATION

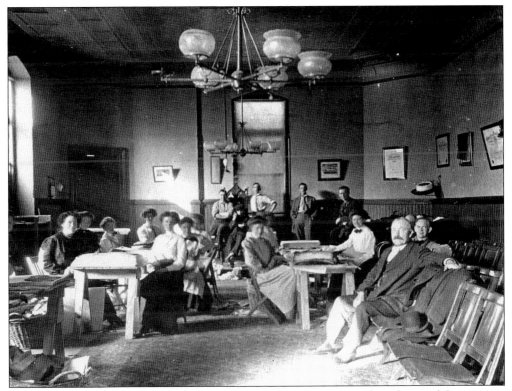

William Berwick, an expert in document preservation, came from the Library of Congress to help in the work of salvage and restoration of what he termed "[state archivist] Mr. Van Laer's treasures." He also documented the restoration in photographs. He titled this image, "Some of the burnt out clerks helping in the work of restoration."

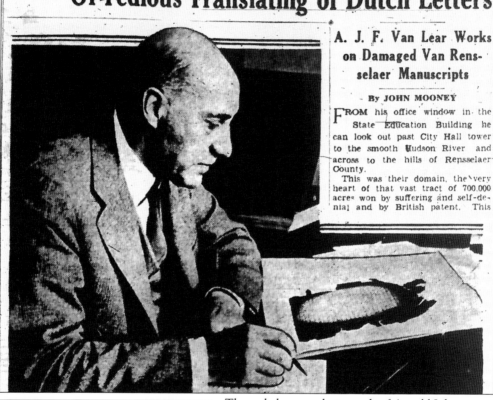

State Archivist Lives in Past During Days Of Tedious Translating of Dutch Letters

A. J. F. Van Lear Works on Damaged Van Rensselaer Manuscripts

By JOHN MOONEY

FROM his office window in the State Education Building he can look out past City Hall tower to the smooth Hudson River and across to the hills of Rensselaer County.

This was their domain, the very heart of that vast tract of 700,000 acres won by suffering and self-denial and by British patent. This

The only known photograph of Arnold Johan Ferdinand van Laer was taken for this *Albany Evening News* article in 1932. At the time of the fire, Van Laer, the state archivist, was a world-renowned authority on colonial Dutch records and history, especially known for his translations. According to Charles Gehring, shown at left, currently the chief translator of the remaining Dutch records, Van Laer was traumatized by the fire, so much so that "it would be almost a decade before he would take up the translator's pen again." In 1932, Van Laer recalled, "For thirty-six hours, firemen played water on the debris . . . When we could get to them we laid the letters out between blotters as fast as possible. We had 70 people doing nothing else . . . Now I am trying to translate them. It is heartbreaking work sometimes."

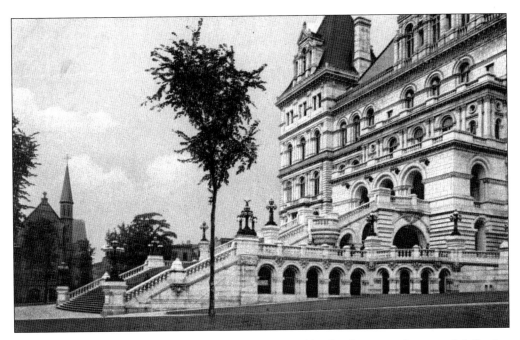

The Calvary Baptist Church, at State and High Streets, offered its basement for a month following the fire. According to the meeting minutes of the board of regents from June 22, 1911, the Education Department "filled it with the dirtiest and wettest of our salvage from the Library, to the manifest injury of carpets, furniture, walls, etc. This aid has not only been given to us freely and . . . there has been no apparent expectation of pecuniary return." The regents recommended "putting the walls and furnishings of its Sunday School room in as good condition as before the fire." In the image of the State Street entrance to the capitol, the steeple of the church is on the right. The church was destroyed by fire on February 10, 1926.

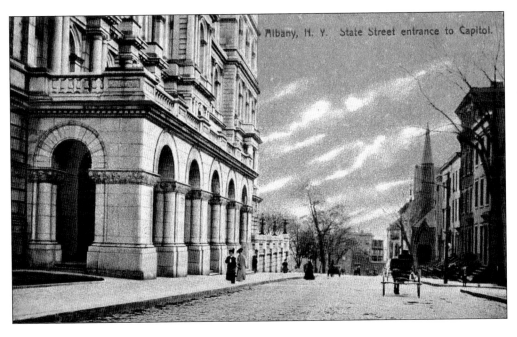

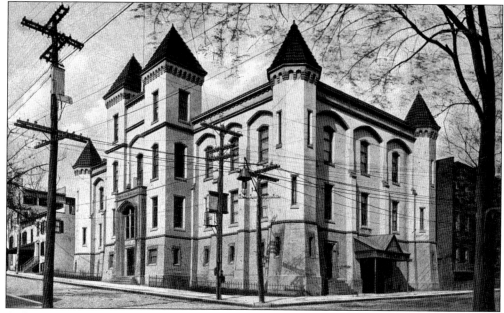

A. J. F. van Laer remembered, "On Thursday morning, as soon as the building had sufficiently cooled to allow the salvage of books and papers . . . [we] secured the help of . . . staff who worked with zest . . . Many of the volumes were so hot that they could hardly be touched with the hand and some were actually burning along the edges." On the third floor of the Catholic Union building, at Eagle Street and Hudson Avenue, "a force of experts" was "engaged . . . in the delicate task of repairing countless" one-of-a-kind documents. The building's "great dance hall and auditorium" was "filled with shelving into which [were] being sorted the thousands of books, duplicates four months ago, but 'the library' to-day."

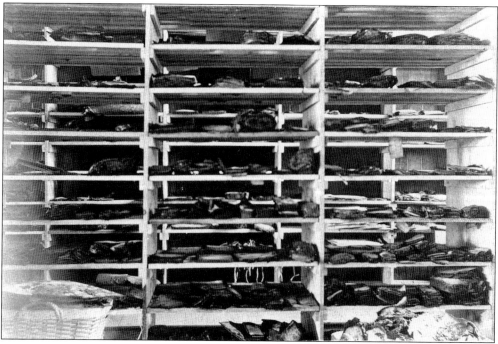

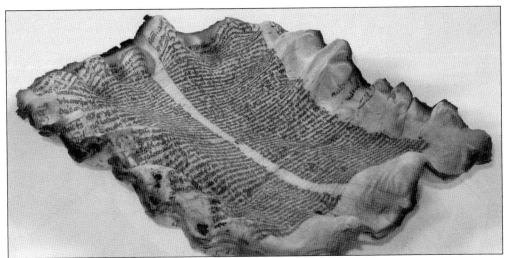

An untreated medieval Latin parchment, recovered from the 1911 fire, shows the combined effects of both water and fire. Most salvaged manuscripts had been originally mounted on heavy sheets with wide margins and then bound into volumes. The first step was to remove all the charred and water-soaked covers. The volumes were placed on hastily built slat shelves and then taken apart leaf by leaf. Each leaf was first laid between newsprint papers for drying and then, after 24 hours, placed between sheets of heavy blotting paper. After 24 hours, each leaf was removed to a second blotting paper. At all stages pressure was applied to facilitate the drying and keep the documents from wrinkling. After having been saved from fire and water, the race for two weeks after the fire was to save the papers from mold and mildew.

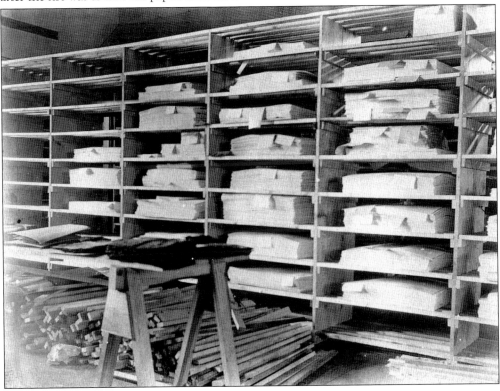

The Van Rensselaer manor was a colonial Dutch land grant that encompassed all of Albany County and the adjacent Rensselaer County. It controlled landholdings in these areas from the 1600s through the 1840s. On November 29, 1910, as stated in the documents themselves, the manor papers were "deposited for safe-keeping in the New York State Library." In accepting the papers, the library agreed to arrange them "as may seem best to serve the purposes of historical research." The agreement was signed by education commissioner A. S. Draper and Eugene Van Rensselaer.

Carefully preserved in the hands of the Van Rensselaer family for more than 250 years, the Van Rensselaer Manor Papers were so severely damaged in the 1911 fire that hardly a single page was left intact, and utmost care and patience is required to translate them. This remnant of a 1643 letter from Arent van Curler to Kiliaen van Rensselaer, the patroon, vividly depicts the ravages of the fire.

Van Laer's efforts saved thousands of documents related to the early Dutch colony in New York, including this memorandum of Kiliaen van Rensselaer to Andriaen van der Donck, July 18, 1641. Van der Donck served as the *schout* (sheriff) of the manor, essentially managing the property for Van Rensselaer, who never came to New Netherland. Although the paper is badly charred around the edges, a significant amount of legible text remains.

Van Laer toiled daily for hours on end in freezing temperatures, and even through a drenching downpour from the ceiling above, while the workmen above handed down charred remnants that he inspected and sent on for restoration. One piece recovered was Maria Van Rensselaer's *c.* 1675 account with a local baker, showing the purchase of *Sinterklaas* (Santa Claus) goodies. This may be the earliest record of the celebration of the feast of Saint Nicholas in the New World.

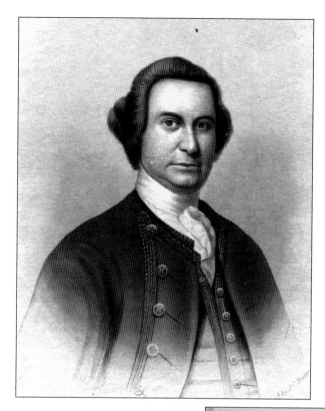

For several years, a staff of from 5 to 10 persons worked on restoring as much of the rescued manuscript material as it was found practicable to restore. Chief among their efforts was the restoration of the papers of Sir William Johnson (1715–1774), a prominent military officer and principal agent for Indian affairs during the closing years of English colonial rule in New York State.

The Johnson papers are an invaluable source for political, military, and social history of the colonial era. One of the items restored was this letter from Johnson to Goldsbrow Banyar, June 19, 1755, concerning provisions of troops and supplies during the preliminary campaign of the French and Indian War.

Joseph Gavit knew that the library's folio prints of Audubon's *Birds of America* were somewhere in this room. Located in a closet, they were "buried to a depth of six or eight feet with bricks, mortar, wood and paper, ashes and twisted girders. But I got two men . . . digging there, and a leftover fireman ('Glory' Kearns!) was playing a hose on the still smoking debris. . . . [O]verhead hung the collapsed north stack, and the cooling process was constantly loosening pieces of brick." At noon, all but Gavit left for lunch. "[B]y the time the men were back, I was ready to hand up the remains. . . . The plates were badly burnt around the edges. . . . They were hot when I took them out, and could not have lasted much longer, as some of the wooden shelves under and above them were still burning."

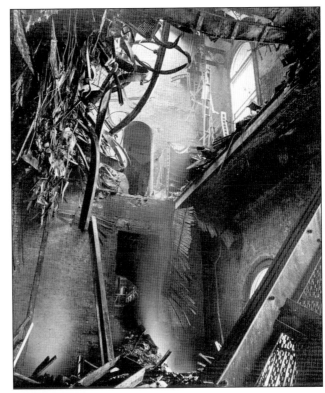

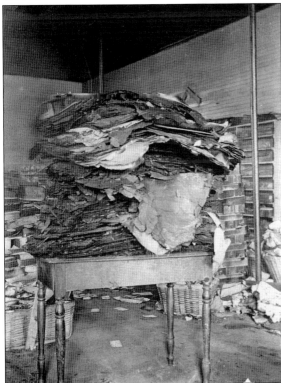

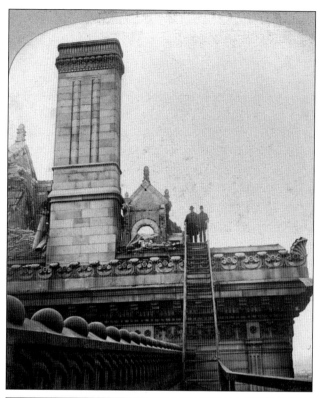

Two unidentified men have climbed to a precarious roof-top vantage point, following the fire. An earlier view shows firemen battling the flames from the same position. Joseph Gavit, recounting early salvage efforts, describes one such journey leading to a lucky find: "The writer, with Mr. Champlin, had gone out onto the roof of the western approach to look at the building from that point. Every window was gone—except one, a disc of glass hardly 6 inches in diameter. That window was one of two alike in the little room where [the War of 1812 records] had been stored. . . . Like a flash came the truth—this room was fireproof because [it was] unventilated! Securing a ladder, we [ventured out] over the still smoldering gallery, to this room, where we found the door burned down but the contents little injured."

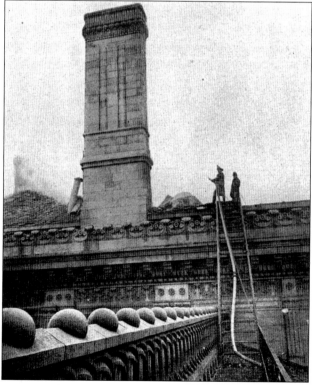

In 1911, Harlan Hoyt Horner, seated at a conference table in this 1961 photograph, was an assistant to education commissioner Andrew Sloan Draper, pictured at right. Hearing of the fire, Horner immediately set out for the capitol, intent on rescuing the library's "treasures," which, some years previously, commissioner Draper, fearing disaster, had secured in a fireproof safe. As reported in the *Knickerbocker Press*, "About 4:30 o'clock on the morning of the fire . . . Horner . . . telephoned the commissioner for the combination of the safe, explaining that the documents were in immediate danger. The combination was sent down and the documents removed to the residence of John E. McElroy, in State Street, where they will be cared for." Horner's timely action saved a collection of manuscript rarities that included George Washington's farewell address and a handwritten draft of Abraham Lincoln's Emancipation Proclamation (acquired for the library in 1864).

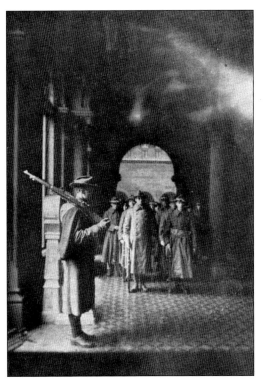

According to the *Albany Evening Journal*, "At 3 a.m. Adjutant General Verbeck telephoned the armory and directed Night Watchman Todd to notify Major Staats and the [National Guard] company officers of the fire and request that they send as many men as they could collect to his office to assist in removing the war records and other valuable papers. . . . In less than an hour a volunteer force of men . . . were at the Capitol." Shortly after 9:00 a.m. on March 29, the capitol was placed under military guard. Company D of the 10th Regiment, based in Albany, and companies from the 2nd Regiment, which came down from Troy and Cohoes, stood guard duty and aided in salvage operations. The state armory, at Washington Avenue and Lark Street, three blocks from the capitol, was designed by Isaac Perry and built between 1889 and 1891.

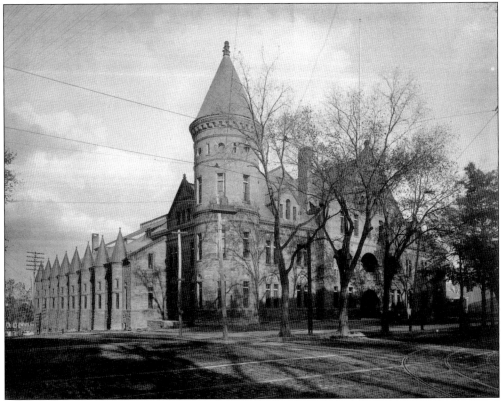

A reporter for the *Knickerbocker Press* wrote for the March 30, 1911, issue, "The clarion tones of the bugle sounded and re-echoed through the arched corridors of the massive building as the [National] guard was changed and the clank of swords of officers could be heard as they hastened here and there." On April 10, the *Times Union* reported, "The soldiers saved thousands of dollars worth of valuables, worked like truck horses among the ruins . . . clearing up debris, moving desks and other office furniture and guarding valuables." The men were paid by check on April 13. According to the *Albany Evening Journal*, "[A]s soon as it became known that [the checks] were ready all hands arranged to be on deck. The men . . . received their checks, and were not long in exchanging them into cash in the various stores on the hill."

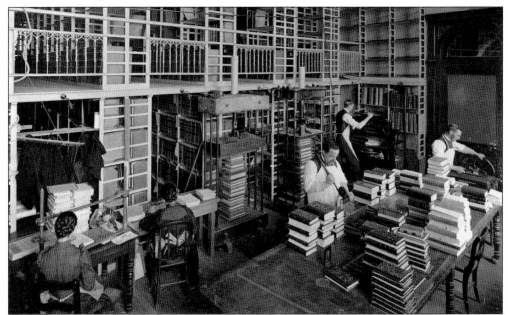

From 1890, the library had its own bindery. The sewers, gilders, and binders shown here were skilled artisans. Initially, as state employees, they received what Joseph Gavit called "ridiculous wages" with "no binders' union interference." Wages improved in 1902, when the binding was contracted to a commercial firm, Clapper and Van Wely. Destroyed by the fire, the bindery, now essential to salvage and recovery work, quickly reopened in the loft of the Lyon Block on Hudson Avenue, adjacent to the Albany public market. Writing in a 1954 memoir, Gavit noted that at least two of the binders who were working at the library in 1902 were still there 52 years later. Even Walter Van Wely, a founding partner of the firm, had continued until 1952, when, at "something over 80" and in failing health, he retired.

Room 71, located in the northwest tower, had been doing service as the New York State Library School's lecture room since 1900. Upon hearing "news of the State Library conflagration," Chalmers Hadley, class of 1907, remembered thinking, "Well, room 71 is warm at last!" Joseph Gavit wrote, "The northwest tower room (Library School) was apparently the last to burn. There was comparatively little in this room to burn, and the wind was the wrong way to allow its burning to be noticed from the street. There were no mezzanines here as there were in the southwest tower. It had probably been burning slowly all the time—not noticed until the woodwork near the windows burned. The desks of the Library School occupied the greater part of the room."

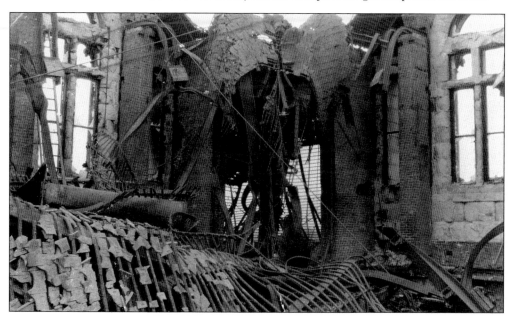

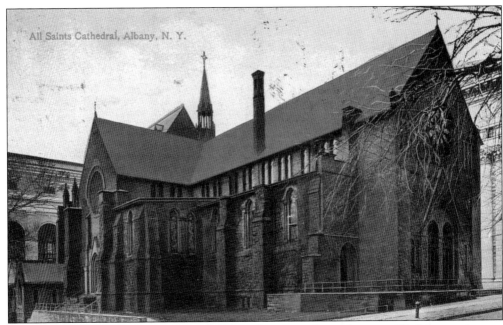

The Cathedral of All Saints (Episcopal), located on Swan Street between Washington Avenue and Elk Street, offered the third floor of its guild house to the library school until its new rooms in the State Education Building were ready. Elizabeth Potter, class of 1912, wrote that when the students returned to school in September, the "gloomy loft of the guild house . . . had been transformed into a pleasant study room and the walls lined with a splendid collection of books." The cathedral, the dream of Bishop William C. Doane, was the first Episcopal cathedral in America and was built on the English model of church, hospital, convent, and school. Begun in 1884, it opened for worship in 1888.

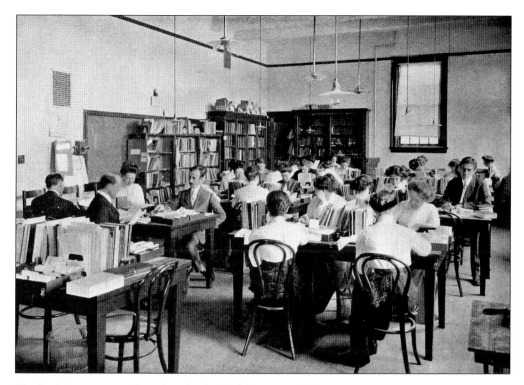

Elizabeth Potter remembered, "The fire had been terrible but if it had to be, we were glad it had come at this time. Our recent examination in shelf and accession work had caused us many pangs of anxiety but . . . our examination papers were no more. . . . [O]ur joy was short lived for everything was lost except one small iron box . . . contain[ing] the examination papers, only blackened a little along the edges." Between April and September, the library school's study room was on the first floor of the science building of the State Normal School (now the University at Albany's downtown campus) on Western Avenue. The science building (left), a structure housing an auditorium and gymnasium (right), and the central building, containing offices and classrooms, opened in the fall of 1909, replacing the building that had burned in 1906.

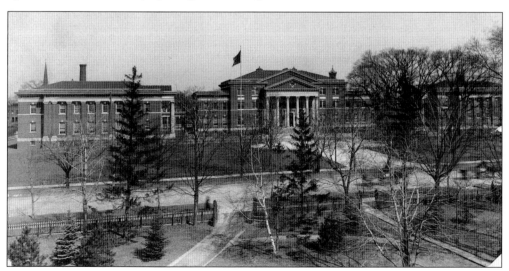

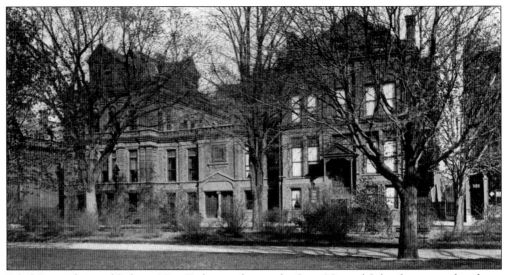

Ethel Everingham, of Delmar, New York, a student at the State Normal School, wrote in her diary, "[T]he Capitol is about two thirds burned up and our wonderful library totally destroyed. . . . [A]lmost the entire Education department landed on us. . . . All the teachers on the first floor had to . . . hang out where they could. . . . They . . . filled the rooms with desks and typewriters . . . They had the main hall full of cabinets, stray arm chairs and other such truck. . . . I . . . do hope they won't spoil our beautiful building. . . . I saw one man spit as he went down the front steps and I was mad enough to choke him. I wonder if they'll smoke!" The old school building was located on Willett Street from May 1885 until it burned in a "spectacular blaze" January 8, 1906.

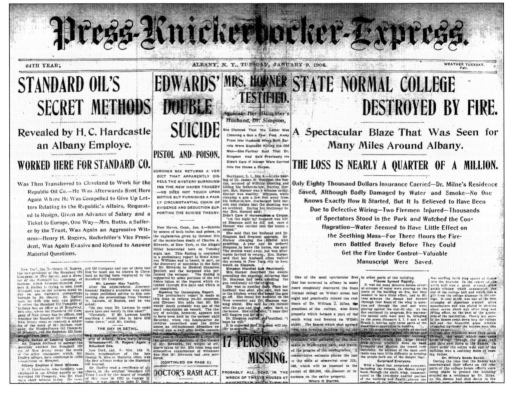

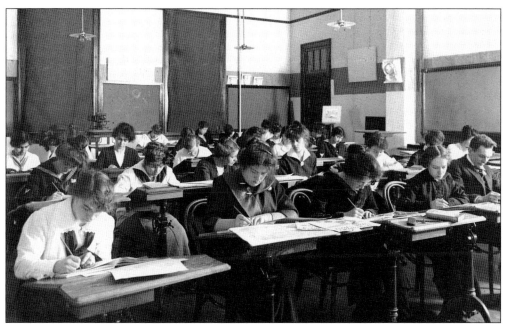

On April 12, Ethel wrote, "Those old Educational fogies are still in our house and if outward appearances are any proof are apt to stay there the rest of this year and the whole of next. They have moved all their beastly office furniture into our class rooms and tacked the names of the occupants of the room on big white signs on the doors and we have been so careful not to mar our beautiful new building even with a pin mark! It's very provoking but we cant [sic] help it so I suppose we may as well follow Dr. Aspinwall's advice and profit by the experience." Shown here are a classroom and the auditorium of the new State Normal School that had opened on Western Avenue in 1909.

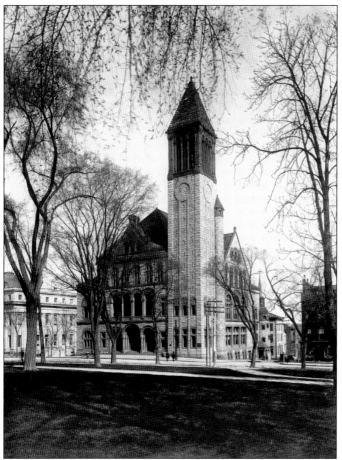

On March 29, the state assembly passed a resolution to "accept the offer of the city of Albany to use its city hall as a place of meeting pending the repairs" to the capitol. The state senate concurred and city hall was "designated as the Capitol of the State of New York for the purpose of legislative sessions and the transaction of legislative business." City hall, just across the street from the capitol, on Eagle Street between Maiden Lane (now Corning Place) and Pine Street, was completed in 1883, replacing a structure that had burned on February 10, 1880. (Icicles hanging over the front entrance are remnants of efforts to extinguish the fire.) The old hall was designed by Philip Hooker, who also had designed the old capitol; the new city hall was designed by Henry Hobson Richardson.

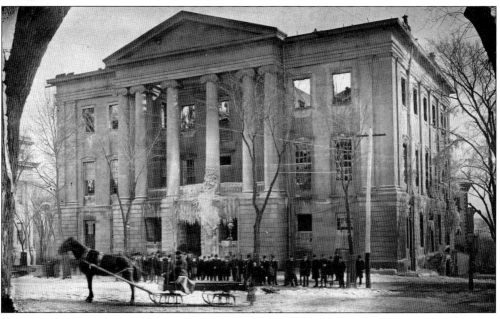

Five

"WE ARE

INEXPRESSIBLY SHOCKED"

REACTIONS TO THE FIRE

James I. Wyer succeeded Melvil Dewey as state librarian. From the morning of March 29, 1911, until 1938, he worked to rebuild his library. Law librarian Frances Lyon recalled, "That morning we all walked up to the State College auditorium for a meeting hastily called by Dr. J. I. Wyer. Everyone was on edge and Dr. Wyer was obviously greatly shaken, as he explained the situation and urged us to carry on." Librarians and friends across the country—many of them former students at Albany—sent letters of sympathy (overleaf) and offers of help. Wyer's almost pro forma response was first to acknowledge the disaster—"The fire is bad enough. We cannot tell yet just how bad, but it looks as if it couldn't have been worse"—and simultaneously declare his determination that "we hope to make a wonderful recovery."

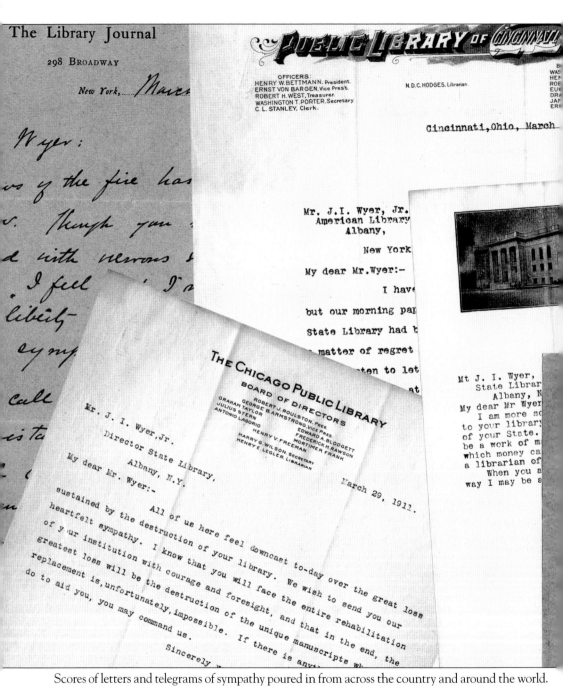

The Library Journal

298 BROADWAY

New York, Marc...

Wyer:

...s of the fire has

... Though you

...d with visions

... I feel ... I'

...liberty—

...ey my

...call

...is to

PUBLIC LIBRARY OF CINCINNATI

OFFICERS:
HENRY W. BETTMANN, President.
ERNST VON BARGEN, Vice Prest.
ROBERT H. WEST, Treasurer.
WASHINGTON T. PORTER, Secretary
C. L. STANLEY, Clerk.

N.D.C. HODGES, Librarian.

Cincinnati, Ohio, March

Mr. J.I. Wyer, Jr.
American Library
Albany,

New York

My dear Mr. Wyer:—

I have

but our morning pap

state Library had t

matter of regret

...ten to let

...at

Mt J. I. Wyer,
State Librar
Albany, N
My dear Mr Wyer
I am more so
to your library
of your State.
be a work of m
which money ca
a librarian of
When you a
way I may be a

THE CHICAGO PUBLIC LIBRARY
BOARD OF DIRECTORS

ROBERT J. ROULSTON, Pres.
GEORGE B. ARMSTRONG, Vice Pres.
GRAHAM TAYLOR
JULIUS STERN
ANTONIO LAGORIO
EDWARD A. BLODGETT
HENRY V. FREEMAN
FREDERICK H. RAWSON
MORTIMER FRANK
HARRY G. WILSON, Secretary
HENRY E. LEGLER, Librarian

Mr. J. I. Wyer, Jr.
Director State Library,
Albany, N.Y.

March 29, 1911.

My dear Mr. Wyer:—

All of us here feel downcast to-day over the great loss
sustained by the destruction of your library. We wish to send you our
heartfelt sympathy. I know that you will face the entire rehabilitation
of your institution with courage and foresight, and that in the end, the
greatest loss will be the destruction of the unique manuscripts wh
replacement is, unfortunately, impossible. If there is anyt
do to aid you, you may command us.

Sincerely

Scores of letters and telegrams of sympathy poured in from across the country and around the world. Former state library staff members and library school students, fondly recalling their old Albany connections, reacted almost as if a cherished friend or close relative had died. Administrators

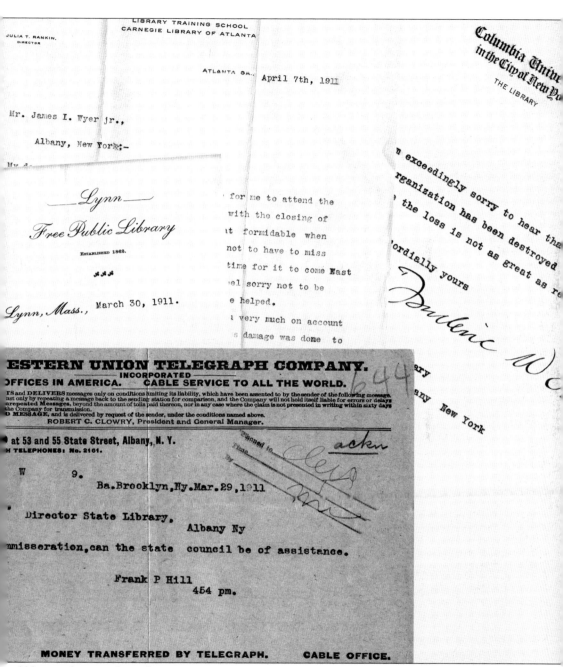

LIBRARY TRAINING SCHOOL
CARNEGIE LIBRARY OF ATLANTA

JULIA T. RANKIN,
DIRECTOR

ATLANTA GA., April 7th, 1911

Mr. James I. Wyer jr.,

Albany, New York:-

My d...

Columbia Univ
in the City of New Yo
THE LIBRARY

Lynn

Free Public Library

ESTABLISHED 1862.

Lynn, Mass., March 30, 1911.

for me to attend the

with the closing of

t formidable when

not to have to miss

time for it to come East

el sorry not to be

e helped.

very much on account

s damage was done to

exceedingly sorry to hear the
rganization has been destroyed
the loss is not as great as re
ordially yours

New York

of libraries large and small sent encouraging words, expressions of dismay, offers of duplicates from their collections and anxious queries about the well being of their Albany colleagues. Such sentiments were echoed by library users near and far who added their notes to the growing pile.

Non-partisan, non-sectarian, non-sectional

Civic League of Albany

To advance the highest interests of the city of Albany through systematic federation of all associations and individuals willing to cooperate for the common good.—*Constitution, art. 2.*

Lake Placid Club N Y 11 Ap 11

J I Wyer Jr
State Library
Albany N Y

Dear Wyer: I got my first news of the fire in a letter from an architect in Paris and another from LaFontaine of the International Institut who is coming at once for a conference over the D C. I was ill and the doctor did not dare let me know of the awful disaster. Just a word today. The bilding which is only the shell may burn, the books which were our tools may burn; but the chief thing, the spirit and influence of the State Library and the Library School you cannot burn or drown or down. As wide as civilization bilds libraries, the influence of our library has reacht and will reach and no disaster can be more than a temporary interruption of its good work. I know in advance that you will find the old staff pure gold in this time of trial. If necessary they will work in water to the knees and live on crackers and cheese. There never was in the capitol any staff in any department with the whole-sould devotion to public duty that we had in the library. Finally, don't be scared, bad as it is you will keep finding that it might have been worse. I read the next days papers, but I know that when you get at it carefully you will unfahet thousands of books that will be useful even if staind with fire and smoke and that the loss, bad as it is, will not prove as total as reported.

Melvil Dewey, James Wyer's predecessor, living in retirement and gravely ill in March 1911, initially had been shielded from any news of the fire. Finally, on April 11, Dewey wrote Wyer, urging him to rely on his loyal staff in rebuilding: "You will find the old staff pure gold in this time of trial. . . . [T]he chief thing, the spirit and influence of the State Library . . . you cannot burn down or drown." Note: The "misspellings" in Dewey's letter are intentional; Dewey was an advocate of simplified spelling, which recommended easier spellings of English words, even changing the spelling of his first name from Melville.

Thank Heaven the richest state has been educated to believe in its library so fully that no one for a moment will dout its replacing it as rapidly as practicable in its new home. You have my heartfelt sympathy in the extra burden it has thrown on you and if there is anything I can do or any of my personal library material that you can use, it is at your disposal.

D H Very truly *Melvil Dewey*

According to *The Telephone Review* of April 1911, telephone company men "worked side by side with the firemen . . . wading through water at times six to eight inches deep . . . removing the greater part of the telephone equipment" exposed to flames. Only 31 of the 197 Bell telephones in service in the capitol were lost, and it was thought "some of these may yet be saved." According to the *Knickerbocker Press*, when the work at the switchboard threatened to swamp the "hello girls" on duty, an "automobile was sent to the homes of girls who could not be reached by 'phone and word left for them to report to work" and, as stated in *The Telephone Review*, "Mr. Donnelley and Mr. McDonough of the Traffic Department . . . raid[ed] all nearby bakeries for rolls and eggs and in a very short time breakfast was served" to the operators. Many of the girls were on duty for 14 and 16 hours.

As reported in the April 1911 issue of *The Telephone Review*, officials, working out of the New York Telephone Company headquarters at the corner of Maiden Lane and Chapel Street, made sure that "wagons loaded with switchboards, wire and apparatus were kept in waiting at the storeroom and just as soon as notice was received of a new location for the office of some one of the burned-out State departments, a telephone message was sent to the shop and equipment was rushed to the new address and installation made at once." The company used the thank-you letter from Commissioner Draper in its advertisement in the April 7 issues of the local newspapers, stating that "Bell telephone service with the force behind it is yours to command in any emergency" and directing readers to see the letter printed on another page of the newspaper.

The Capitol Fire.

Bell telephone service with the force behind it is yours to command in any emergency.

We print on another page in this paper a letter of appreciation from the State Commissioner of Education, commending our good work during the State Capitol fire disaster.

Read it.

Bell telephone service best for any emergency.

NEW YORK TELEPHONE Co.
74 Chapel St.

The Hudson River Telephone Company, a predecessor of the Bell and New York Telephone companies, was located at 468 Broadway. According to the *Albany Argus*, its switchboard was destroyed by fire March 9, 1891, in "a carnival of fire . . . [and] a novel, but dangerous display of flashing and vari-colored lights," caused by trolley wires coming in contact with telephone wires, leaving the city almost completely without telephone service. In 1915, a new headquarters building, standing at the southwest corner of State and Park Streets, was completed. It was 10 stories high and, as reported in the *Albany Evening Journal*, was "[a]bsolutely fireproof, practically no wood . . . [was] used in the structure, and all the steel used [was to] be encased in concrete. . . . Exclusive of halls, elevator and toilets, the building . . . contain[ed] over 80,000 square feet or about two acres of working space."

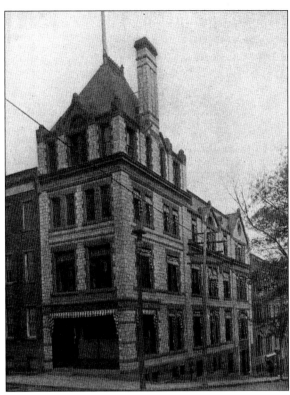

William Herman Hopkins's sermon at the First Presbyterian Church, located at State and Willett Streets, on Sunday, April 2, was "Tried by Fire." The sermon, printed in the *Knickerbocker Press* on April 3, warned, "Let a man be careful with his lighted matches and live wires, else he may destroy a greater building than the Capitol; a temple not made with hands but built and inhabited by God."

An enterprising advertising salesman for the *Times Union*, an alert Albany representative for the H. G. Vogel Company, or maybe even the president of the firm designed this advertisement for the Esty automatic fire sprinkler and arranged to have it set in type for the March 29 issue of the *Times Union*! In the haste of preparing the timely advertisement, the typesetter made two spelling errors and one grammatical error.

THE BIG LOSS

TO THE

STATE CAPITOL

would have been

PREVENTED

and the loss of the

State Library

with its priceless volumes, would have been saved had the building been equipped with automatic fire sprinklers.

The Esty Sprinkler

preevnts spread of fire and effetcs great reduction in insurance rates.

Particulars on Request.

H. G. VOGEL COMPANY,
12-14 Walker St., New York City

About 1838, someone borrowed the state library's copy of *Memoirs of Sir Joshua Reynolds*, one of the first books purchased by the library, after its establishment in 1818. The bookplate attached inside the cover was personally signed by the first state librarian, John Cook, and dated September 1819. Because the borrower failed to return it, the book survived the fire. It finally returned to its home in February 1967, thanks to the sharp eye of Mary B. Hoag, librarian at the Beekman Community Reading Center, Poughquag, Dutchess County, New York, who sent the book up to the state library. In an accompanying note, Hoag said the book came "as a gift among other books."

According to Joseph Gavit, Gov. John Alden Dix "guaranteed . . . a full investigation of the causes . . . but he was persuaded otherwise, by those who knew." Gavit felt certain that careless smoking during a booze-soaked party in the assembly library caused the fire. "The details have never come out. But the Legislators came out in time to save their skins, and shut the door." Officially, the fire was blamed on faulty wiring.

A March 30 *Knickerbocker Press* cartoon linked the capitol fire to the notorious March 25 Triangle Shirtwaist factory fire. The paper reported, "The fire was not only terrible . . . but it set the women of Albany to thinking, and thinking very hard, for the holocaust Saturday in New York made the progressive women of the town more than ever anxious to look into the matter of fire inspection and factory laws."

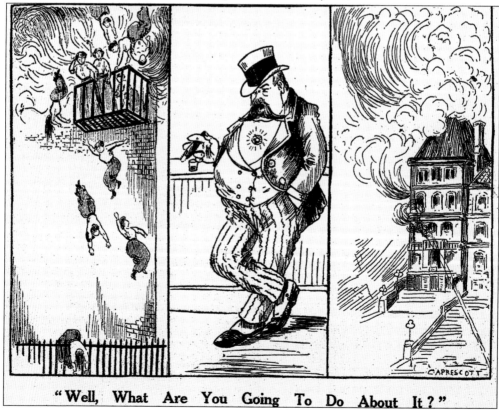

"Well, What Are You Going To Do About It?"

Six

"THE DREAM OF DR. DRAPER"

THE EDUCATION BUILDING AND THE STATE LIBRARY

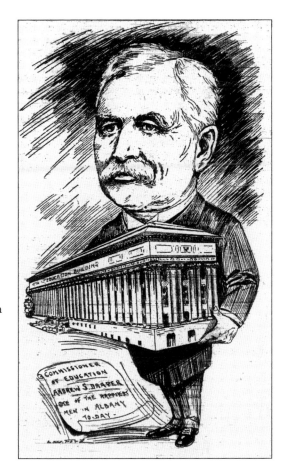

For education commissioner Andrew Sloan Draper, the new State Education Building "had one controlling motive, and that was to consolidate and gain added support and keener energy for the educational activities of the State. . . . The Education Department was quartered in a half dozen places in the Capitol. . . . Its priceless accumulations of books and historical manuscripts could not be properly cared for and were actually in danger from fire."

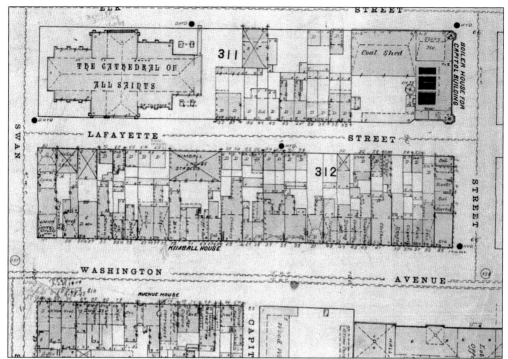

The site chosen by Commissioner Draper and Gov. Frank W. Higgins for the education building had, according to an article in the *Albany Evening Journal,* "few modern buildings" on it in 1906. While the block—shown in this 1891 fire insurance map—at one time had been the "business center of the city," the 140,000-square-foot site had only about 120 "buildings" on it when M. F. Dollard contracted to raze each building and remove its rubble for $5 per building, in 77 days. The contract called for him to begin work May 1, 1906. The *Albany Argus* reported that "a number of the [land] holders are anxious to sell immediately and settle elsewhere." Left standing in the neighborhood was an antiques store, on the corner of Washington Avenue and Hawk Street, that had been owned by the William H. Blake family from 1896 to 1910.

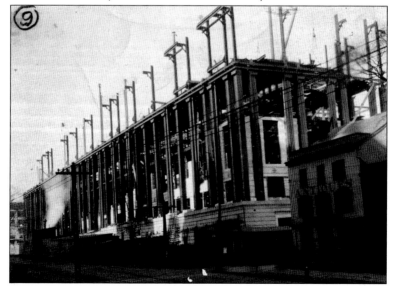

The photograph above shows the buildings on Washington Avenue in 1906 looking east from Swan Street; the image below is the view looking west from Hawk Street. Also removed were the buildings on Lafayette Street between the cathedral and the boiler-house complex. Among the buildings to be torn down was the home of Henry P. Warren, principal of Albany Academy. His house previously had been the residence of Dr. William Buell Sprague, who the *Albany Evening Journal* called "the famous divine, pastor of the Second Presbyterian church," and, on the second floor, Jeremiah Waterman's dry goods store. Also going were William C. Gomph's music store, the Kimball House, a laundry which had replaced Humphrey's drugstore, and Charles W. Lyon's antique furniture store, which had "succeeded Walter's Oyster house, which was a very popular resort" in the 1880s.

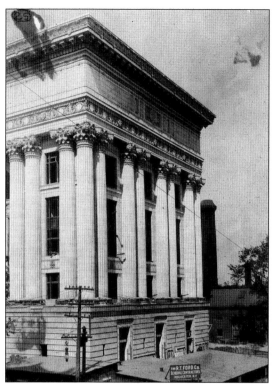

The *Albany Argus* of February 10, 1912, reported the State Education Building would not be ready by April 1, as expected. Although the exterior was "practically completed," the upper two of the four floors in the building were not near completion and much work was in the hands of "many sub-contractors" of the R. T. Ford Company, of Rochester, the general contractors. However, the lease on 162 State had not been renewed.

In November 1911, acting on the suggestion of Bishop William Croswell Doane, the trustees of public buildings adopted a resolution "that, except in case of absolute emergency, no work shall be undertaken on Sundays on the educational building." The cathedral is seen here in the left background of the construction site photograph of the State Education Building taken April 22, 1909. Work on the building began July 29, 1908.

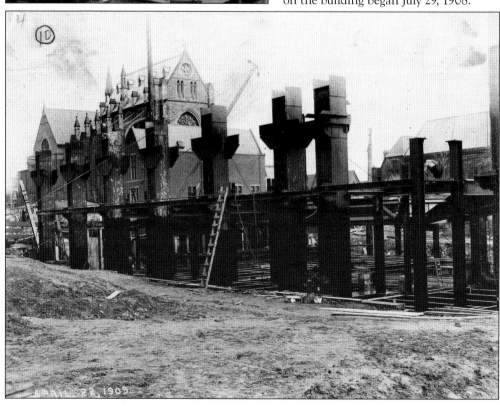

GREETINGS FROM

HISTORIC ALBANY

GOVERNOR HUGHES
COMMISSIONER DRAPER
AND THE
NEW STATE EDUCATION BUILDING
ALBANY, N. Y.

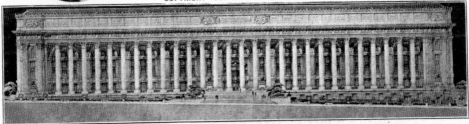

The March 3, 1912, issue of the *Knickerbocker Press* stated that the dedication of the New York State Education Building would be "[o]ne of the most significant events in the history of the country. The building is unique in that it is the first erected by any state for the exclusive use of its educational interests. . . . The dedication . . . is peculiarly appropriate this year as it marks the one hundredth anniversary of the creation of a state system of common schools." The firm of Palmer and Hornbostel won the architectural contract. In choosing the design, Gov. Charles E. Hughes and commissioner of education Andrew S. Draper wanted a building that not only included offices, storerooms, and library and museum space but also was "dignified and imposing. The classical design was selected as best meeting all these requirements."

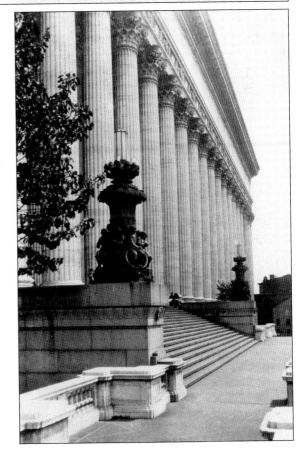

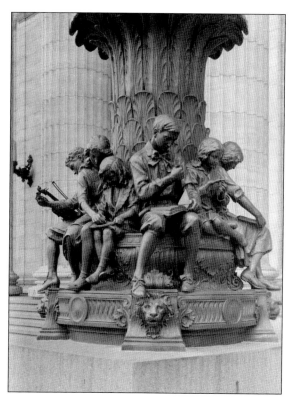

Charles Keck used his nieces and nephews as models for the life-size clusters of children seated around the bronze electroliers (lamp standards) on either side of the steps of the Washington Avenue entrance of the State Education Building. The sculptures typify the two phases of a child's development—mental and physical. One group depicts children at their studies, and the other, children relaxing after play. The boys wear knee breeches, as most of them did in the early 1900s.

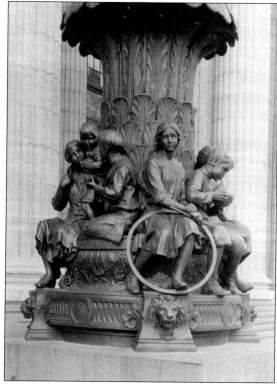

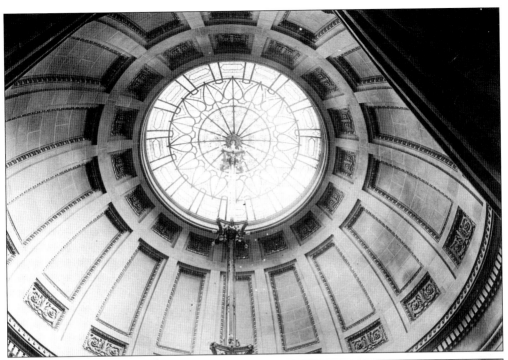

Pictured on this page are a close-up of the chandelier designed by Charles Keck that hangs from the top of the rotunda and a view of the dome from which it is suspended. Carved in giant letters around the cornice are these words: "Here shall be gathered the best books of all lands and all ages. A system of free common schools wherein all the children of this State may be educated. This library aims to uplift the state and serve every citizen." The height of the dome above the second floor is 94 feet.

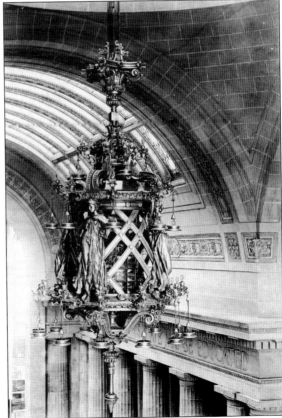

Upon entering the building from Washington Avenue to the right is the massive staircase leading to the second floor rotunda. On reaching the rotunda, several vistas open to view: to the north, a barrel-vaulted corridor leading to the general reference reading room; to the east, a shorter vaulted corridor leading to the technical and medical libraries; and to the west, a similar corridor leading to the law and sociological libraries. Over the rotunda is a circular colonnade that supports a dome in which there is a large skylight. Pictured sitting at a desk on the second floor in the rotunda is H. Lansing Mace, who worked as a reference librarian for the state library from 1962 to 1978.

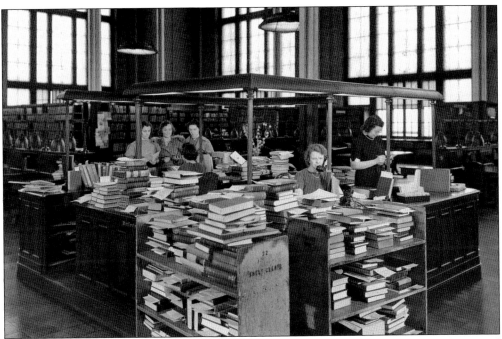

The state library occupied the second and third floors of the education building. On the second floor, the wing to the north was used as the general reading room, equipped with 12 large tables and 60 small ones. The ceiling was two stories high; the windows on the three open sides provided light. According to the *Knickerbocker Press*, in the center of the room (not seen in this photograph) were "landings for five automatic elevators by which rapid access [could] be had to the seven stories of modern steel book stacks" in the basement of the building. The reference desk in the education building in the 1940s stood near the elevators and was staffed by three to six librarians who answered questions from patrons on site and on the telephone; the reference desk in the capitol in the 1890s was staffed by a single librarian.

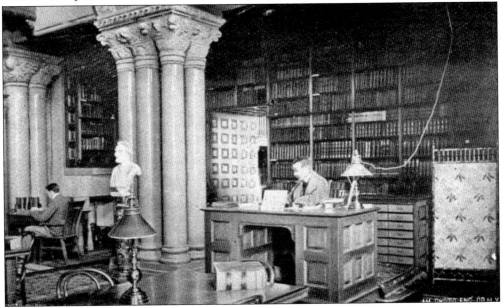

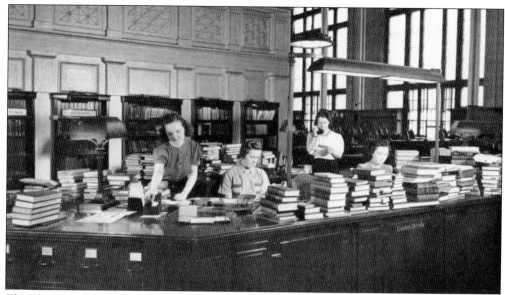

This close-up of the loan desk in the education building in the 1940s contrasts dramatically with the loan desk in the capitol in the 1890s. The newer loan desk is larger and much simpler in design than its predecessor, which was intricately carved oak. To the right of the loan desk in the capitol can be seen the "speaking-tube closet" and card catalog drawers. At the time the photograph was taken, there was still plenty of room for growth in catalog drawers. Carpeting was put down in part of the library in the capitol to muffle the sounds of shoes of tourists, who were constantly parading through the reading room of the library on their tours of the building.

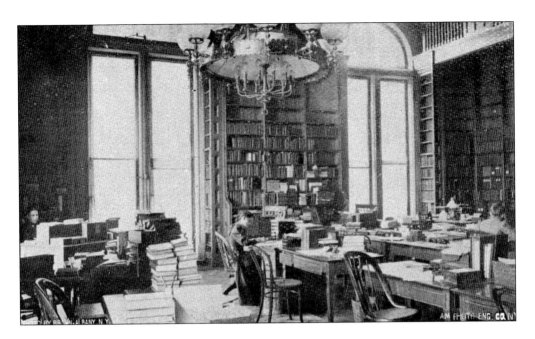

Library catalogs help researchers find books, magazines, maps, and prints in libraries. In the 1880s and 1890s, would-be librarians had to learn "library handwriting," also known as "catalog hand," which stressed legibility and uniformity in writing information on cards for the catalogs. Melvil Dewey deemed it "a very important mechanical accomplishment," even suggesting brands of ink and pens. In 1904, the New York State Library used "Carter's record ink, Stafford's blue writing ink and carmine ink," and L. E. Waterman's Ideal fountain pens were found to be "most satisfactory." With the advent of typewriters, catalog hand was a skill that was gradually lost. The library school's 1910–1911 "Circular of Information" noted, "The use of library handwriting is no longer required. . . . Ability to use a typewriter is . . . important." In 1916, prospective students had to "write catalog cards" using a typewriter.

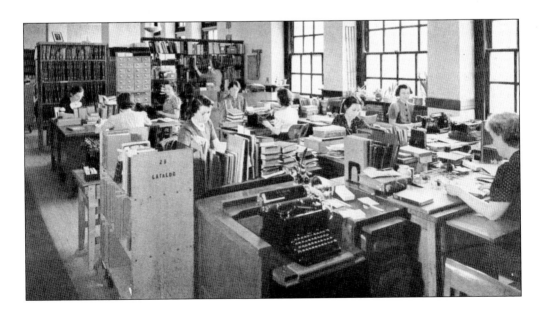

The image at left shows cards written by two individuals in catalog hand and a card that had been typed. All three cards show they survived the fire. The *Albany Argus* reported that, when the library was being reorganized after the fire, "books were pouring in too rapidly to be cataloged completely." The bottom catalog card was created by Joseph Gavit, who, in 1930, not in catalog hand, created a card index to sheet music. According to the *Albany Argus*, Gavit left a note for state library director James I. Wyer: "As the vacation schedule required my presence at your desk for an hour every noon, I used that time in preparing cards for the entire sheet music collection, so that now we have a rough title index of all our sheet music bound and unbound making 1600 cards. I have considered this well worth doing even in a rough way."

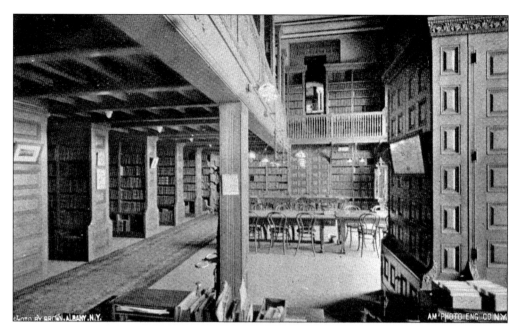

A law reading room in the capitol is shown in an 1890s-era photograph (above). The c. 1940 photograph below shows the law library in the State Education Building. "For weeks before the fire," assistant law librarian Frances Lyon recalled, "I had heard discussions on the problem of transferring books from the library across Washington Avenue to the new Education Building. . . . I recall something about a chute. . . . But the fire ended all this planning and here we were with a huge building with miles of shelves and no books to go into it. When I first saw the new law library reading-room, extending almost half a block . . . it seemed that it would take a life-time to fill it up." Promoted to law librarian in 1930, Lyon retired in 1950. Reflecting on her career, she wrote, "I always say 'I date from before the fire.'"

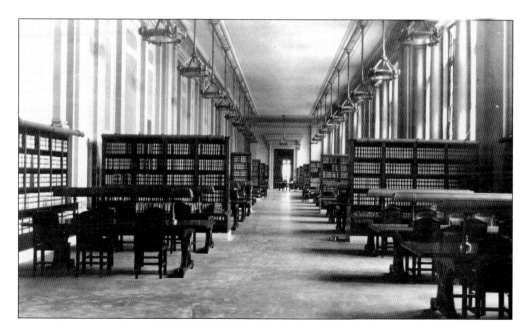

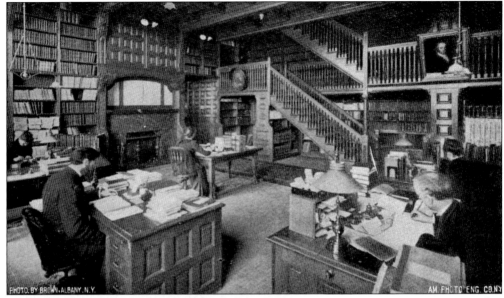

On May 21, 1891, an act to provide for the acceptance and care, by the regents, of the medical library donated to the state by the Albany Medical College, was approved by the governor. By 1911, the library held 20,000 volumes and about 12,500 pamphlets; all were completely destroyed by the fire. The *Albany Argus* reported that, at its meeting on April 12, 1911, the Medical Society of the County of Albany adopted resolutions asking the legislature for "a speedy restoration of the medical library, in which physicians have become accustomed to go for ready reference to works imparting knowledge on modern medicine." Through purchase and gifts from the personal libraries of physicians, the medical library included over 49,000 volumes by 1941. Any hospital, health laboratory, registered physician, or nurse could borrow materials.

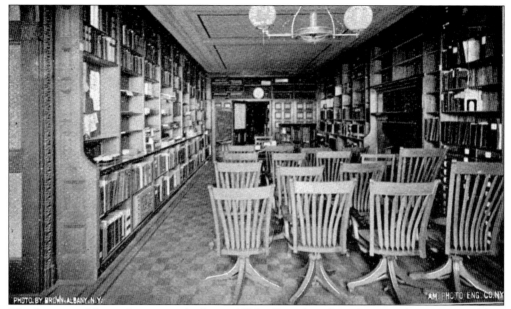

The American Library Association had since 1876 collected catalogs, forms, explanatory pamphlets, and samples of supplies and products used in library work. The collection was donated to the library school at Columbia College and moved with Dewey to Albany. The items were housed in the so-called "Bibliothecal Museum," in room 31A, which also served as a lecture hall for library school students.

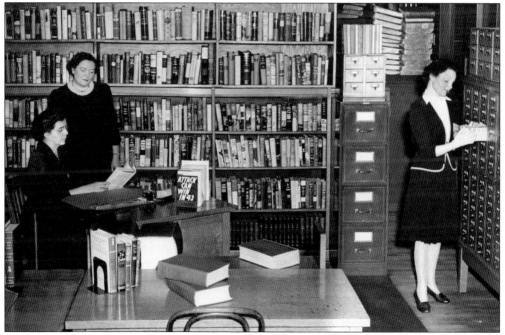

Staff in the state library's Book Information Section—shown in this 1943 photograph—published the *Bookmark*, a collection of short reviews of "worthwhile" books. Staff examined or read hundreds of books yearly, and by 1943 were sending copies of the reading list not only to libraries but also to army camps. Note the *Attack Can Win in '43* book on the desk in the center of the photograph.

Of 10,000 archaeological artifacts and ethnographic objects in the state museum, only 1,500 were recovered from the 1911 fire. Nevertheless, the museum was reestablished in the State Education Building, where, like the state library, it grew and prospered. Within a decade, it had filled every hallway, nook, and cranny in the building with collections. Shown are two museum exhibits—the fossil forests of Gilboa, New York, and the Hall of Vertebrate Paleontology.

Seven

"Perched Upon the Highest Hill"
Building for the Future

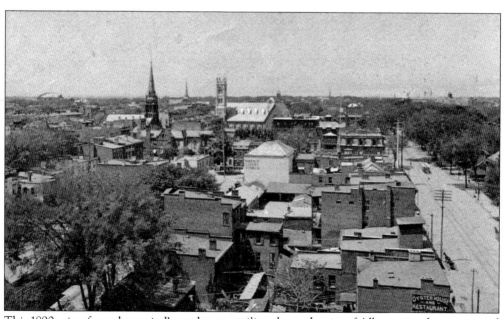

This 1890s view from the capitol's southwest pavilion shows the city of Albany stretching westward as it grows. The planners and architects who developed the capitol and the complex of government buildings around it were constantly striving to create a structure that would dominate the city—always the tallest building on the highest hill, a fitting symbol of the power and majesty of state government.

The *Times Union* reported that the embers of the capitol fire had barely cooled before there was talk that "the additional space which [would] be had in the capitol when the burned portion [was] reconstructed and the state department of education and the state library [were] housed in the state education building [would] not be adequate for the needs" of state government. A fire in the North Pearl Street building housing the state police on January 28, 1925, drew attention to the fact that many state offices were, according to the author of *The State Office Building in Albany*, housed in "private houses, garages, [and] abandoned factories" around Albany. Gov. Alfred E. Smith's reorganization of state government, "consolidating 187 bureaus, boards and branches into 18 large departments" would, reported the *Binghamton Press*, provide for "maximum efficiency and economy" which would take effect on January 1, 1927, served as the impetus to build a new state office building.

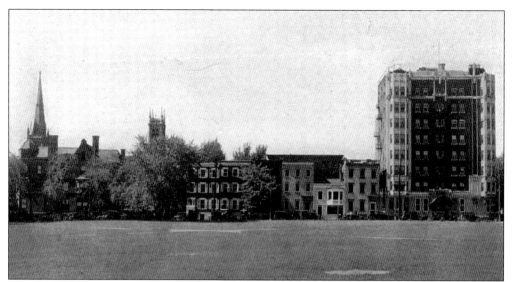

The site for the new office building was the block on South Swan Street, stretching from State Street to Washington Avenue. One of the buildings on the site was the eight-story Fort Frederick apartment building. According to the *Binghamton Press*, it "was hauled west to new foundations [248 State Street] about 400 feet distant from its old location [70 South Swan]. Thousands watched the process which required about three weeks' work and which was done without even so much damage as the breaking of a pane of glass in the apartment structure." As recorded in *The State Office Building in Albany*, the structure was said to be "primarily a utilitarian structure. There [would] be no monumental staircases or other architectural flourishes. On the exterior, little architectural embellishment [was] called for. The harmoniously proportioned symmetrical mass of the building [was] sufficiently pleasing and impressive . . . to make any attempt at ornamentation . . . unnecessary."

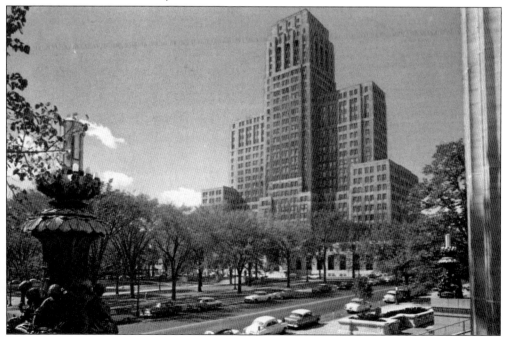

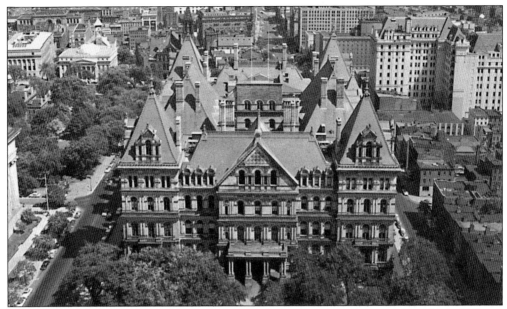

The author of *The State Office Building in Albany* wrote that when the capitol was built, "Albany was a three- and four-story city . . . the Capitol standing above the city and facing the rising sun seemed to symbolize the State's majesty. Since then the many tall buildings constructed in Albany ha[d] blanketed the Capitol and resulted in the loss of its former symbolism. The new office building, dominating the skyline of Albany and forming a background for the Capitol, [would] re-establish this older symbolism of the State's sovereignty." Gov. Smith laid the cornerstone on February 28, 1928, and on May 15, 1946, the building was dedicated as the Gov. Alfred E. Smith State Office Building. The view of the capitol, taken from the observation deck, provides a glimpse the capitol's inner courtyard; the view of the State Education Building, taken from the steps of the office building, was taken in the 1930s.

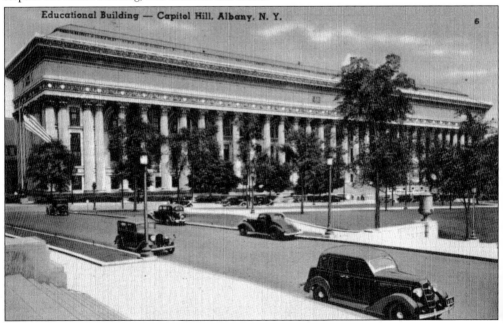

Educational Building — Capitol Hill, Albany, N. Y.

According to the *Knickerbocker News*, the "contemporary glass-and-marble lines" of the education building annex, dedicated May 19, 1960, "contrast[ed] sharply with the Roman classical design of the main building." It had "four high-speed, electronically-operated, self-service elevators" that would "whisk" workers to their offices. The building had air conditioning, "relaxing pastel wall colors . . . recessed fluorescent lighting and acoustic tile . . . [to] "enhance . . . working conditions. Movable metal partitions [allowed] the employees to shift their rooms around to achieve the most efficient arrangement." The building also had a "television studio where the department plan[ned] to make films and hold screenings." It was "built to relieve overcrowding in the main building and to bring together department employees now working in seven rented offices." Education Commissioner James E. Allen, Jr. declared, "It epitomizes education rooted firmly and solidly in tradition but growing responsive and adaptable to changing needs and times."

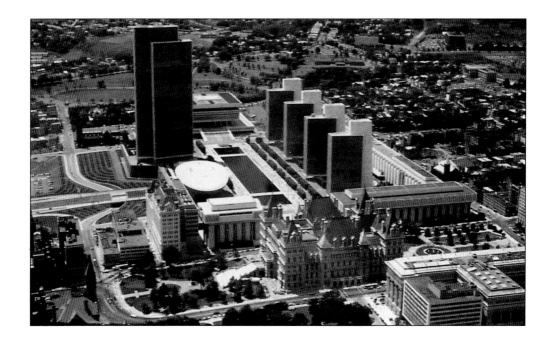

Wallace Harrison designed the 98.5-acre Empire State Plaza, and construction on the 10 buildings began in 1965. The Corning Tower and the four 310-foot state agency buildings were completed in 1973, the Cultural Education Center in 1976, and the Egg in 1978. At 589 feet and 44 stories in height, the Corning Tower is the tallest skyscraper in the state of New York outside of New York City. The Egg, a performing arts venue, houses two amphitheaters. The site is also home to the Robert Abrams Building for Law and Justice (previously known as the Justice Building), the Legislative Office Building, and the Swan Street Building. The capitol also is connected to the Cultural Education Center by an underground concourse. The buildings surround three reflecting pools; rows of square-trimmed trees separate the structures from the pools.

In 1945, Joseph Gavit, dusting off his fire memoirs for the new state librarian, Charles Gosnell, commented, "At this later date . . . it is perhaps worthwhile to say for the benefit of the post-war planners that the new book stack space, expected to last at least fifty years, became inadequate in thirty years! And the conditions of crowding and fire tempting are not far away as a dream."

When the state library moved into the Cultural Education Center (CEC) in early 1978, according to *Inside Education*, it became "the first major library to move and leave its card catalog behind. Instead of the 2,000 drawer catalog . . . readers and staff in the new quarters [would] use computer terminals and microfiche equipment to locate books." The nonpublic "accession card file" did make the move, and staff used microfiche, computers, and the card file to do their work. The 77 miles of shelving in the new facility included three floors of shelving in the basement. The online catalog and computer technology have evolved dramatically over the years, but microfiche and the card file still serve as backups when the computers are down.

On July 1, 1976, as part of nationwide bicentennial celebrations, the Cultural Education Center, the southern anchor of the Empire State Plaza, was dedicated. At the opening, one hall of permanent exhibits in the state museum, the Adirondack Wilderness, was opened to the public. The state library moved over in 1978. Today the CEC also houses the New York State Archives and the Office of Educational Television and Public Broadcasting.

ABOUT THE
NEW YORK STATE LIBRARY

Since it was founded in 1818, the New York State Library has given New Yorkers access to information that captures the state's legal, cultural, political, and social history. The library holds significant medical and law collections as well as extensive collections in state and local history, genealogy, science, and public policy. It is the only state library that is a member of the Association of Research Libraries. In addition, the Talking Book and Braille Library provides audio and Braille books and magazines to New Yorkers who are unable to read standard printed material because of visual or physical disabilities, and the Division of Library Development provides statewide leadership, advisory services, and state and federal funding for New York State's libraries and library systems.

The Friends of the New York State Library is a nonprofit group of readers, library users, scholars, historians, and others whose mission is to stimulate government and public support for the New York State Library. They support the library and its programs through public education and advocacy. They work with state government, library systems, local libraries, and individuals to strengthen, preserve, and publicize the library's collections and services for all the people of New York State. Everyone is welcome to join The Friends.

Select Bibliography

Abriel, Warren W. *The History of the Paid Albany Fire Department: A Story of Fires and Firemen from 1867–1967.* Albany, NY: Argus-Greenwood, Inc., 1967.

"Allen Calls New Wing an Education Symbol." *Knickerbocker Press.* May 19, 1960.

Cecil R. Roseberry Papers, 1960–1970. New York State Library.

Child, Hamilton. *Gazetteer and Business Directory, Albany and Schenectady County, 1870–1871.* Syracuse, NY: The Journal Office, 1870.

Ford, Thomas G., ed. *The History of the Albany Fire Department: A Story of Fires and Firemen from 1664 to 1924.* Albany, NY: J. R. Condon and Sons, 1924.

"Education Bldg. Wing to Be Dedicated Today." *Knickerbocker Press.* May 18, 1960.

Inside Education. Albany, NY: New York State Education Department, June 1978.

New York State Capitol Fire Centenary Commemoration Records, 2010–2011. Manuscripts and Special Collections. New York State Library.

New York State Library Fire Collection, 1899–1942 (bulk 1911–1913). New York State Library.

Roseberry, Cecil R. *Capitol Story.* Albany, NY: State of New York, 1964.

———. *Capitol Story.* Albany, NY: New York State Office of General Services, 1982. Expanded edition.

———. *For the Government and People of This State: A History of the New York State Library.* Albany, NY: University of the State of New York, 1970.

"Sparks" from the New York State Capitol Fire. Albany, NY: Coulson and Wendt, 1911.

The First Quarter Century of the New York State Library School, 1887–1912. Albany, NY: New York State Library School, State of New York, Education Department, 1912.

University of the State of New York. *Souvenir of the Dedication of the New York State Education Building, Albany, October 15, 16, 17, 1912.* Albany, NY: J.B. Lyon Company, 1912.

www.arcadiapublishing.com

Discover books about the town where you grew up, the cities where your friends and families live, the town where your parents met, or even that retirement spot you've been dreaming about. Our Web site provides history lovers with exclusive deals, advanced notification about new titles, e-mail alerts of author events, and much more.

Find Your Place in History.